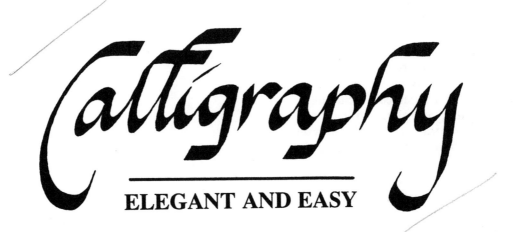

# Calligraphy

## ELEGANT AND EASY

**Joyce Ryan**

BUTTERFLY
BOOKS

Published by Butterfly Books
4210 Misty Glade
San Antonio, Texas 78247
Telephone 210-494-0077

Manufactured in the United States of America

**Library of Congress Cataloging-in-Publication Data**

Ryan, Joyce E.
   Calligraphy: Elegant and Easy
   Bibliography: p.
   Includes index
   1. Calligraphy - Technique I. Title
Library of Congress Number: 94-94049

**ISBN 0-939077-04-3**

Dedicated to three people who have always
encouraged and believed in me:

Mother

Jim

Jerry

## Also by Joyce Ryan

Traveling with Your Sketchbook
Seoul Travel Guide
Scenes of Southern Arizona
Seoul Sketches
The Happy Camper's Gourmet Cookbook

## ACKNOWLEDGMENTS

I extend sincere gratitude to my students for encouraging me to undertake this enormous project. My appreciation and thanks to Corinne Price for her intelligent editorial assistance. I am also indebted to Mark Johnson for his beautiful photographs. Very special thanks to Jim Klar for his helpful criticism and professional advice.

# Contents

**Introduction**

## BASIC SKILLS

## CALLIGRAPHY PROJECTS

## ADDITIONAL INFORMATION

**About the Author**

# Introduction

When you see beautiful calligraphy do you wistfully desire you could write with such elegance? Would you enjoy making crafts that use calligraphy? This book teaches you how to write calligraphy and how to use it to create unique products.

What is calligraphy? Calligraphy is the art of beautiful handwriting. Since you already know how to write, it is an art form that is very easy to learn. Motivation and a modest amount of practice yield spectacular results.

Calligraphy will enrich your life by enabling you to create beautiful art. And, since calligraphy is tailor-made for sharing with others, your projects will become treasured heirlooms for your family and lucky friends.

This book is divided into three parts. Part one gives you comprehensive information regarding the basic skills you need to create calligraphy. First you will develop a basic writing ability; then, you will learn to create a personal style. Part two consists of 30 projects giving step-by-step instructions to creating your art. Numerous examples allow you to copy, or to use as inspiration for your own ideas. Part three contains useful additional information: a list of calligraphy projects suitable as gifts, where to locate special art and calligraphy supplies, and the addresses of calligraphy organizations and newsletters. This section also includes guide sheets.

I encourage you to learn calligraphy because you will discover a source of great pleasure. Calligraphy is both beautiful and fun.

# Equipment

---

Unlike many other art forms, calligraphy does not require a lot of special equipment. All you need to get started is a calligraphy pen, ink, and paper.

## PEN AND INK

There are three basic types of calligraphy pens: dip pens, fiber point pens, and reservoir pens. Regardless of which type you select, it is essential that the pen have a chisel point (Figure 1-1). Understanding how pens function will help you decide which one to buy.

Inks are dependent on the type of pen you use. It is of critical importance that you purchase ink compatible with your pen.

## Dip Pens

A dip pen (synonym: steel nib pen) consists of a chisel point plus holder (Figure 1-2). Calligraphers recommend India ink for these pens because it produces rich, velvety black letters. The ink used in other pens is thinner; therefore, letters lack the density and lushness that India ink produces.

India ink is not the only ink that you can use with a dip pen. Other permanent inks of assorted colors also work well. You can select gold and silver inks, gouache, water-based dyes (I recommend Dr. Martin and Luma brands), liquid acrylics, and tempera paints. These choices give you an infinite color range.

If you select a medium that is very thick and does not flow well, thin it with water and a drop of gum arabic. Gum arabic is available from "Pendragon" (see page 85).

Points (synonym: nibs) for dip pens are available in many sizes which enables you to write from very small to very large letters (Figure 1-3).

Dip pens are loaded with ink manually by either dipping the pen into the ink bottle, then blotting, or by dropping ink into the pen with a special stopper embedded in the ink bottle cap (Figure 1-4). After filling the pen with ink and blotting the point, make several test strokes on a scrap sheet of paper before writing on your good paper. This procedure eliminates the initial problem of excessive ink flow.

Some calligraphers think dip pens are inconvenient and limit spontaneous use. Obviously, filling a dip pen can be a messy process. It would be very difficult to take a dip pen with you everywhere you go or write whenever you wish. Also, when you finish writing you must rinse out the point. If the ink contains shellac, frequent rinsing while writing

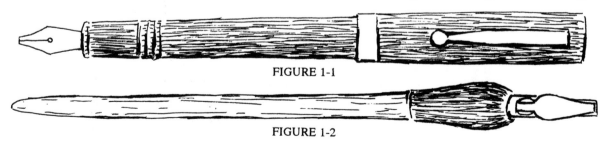

FIGURE 1-1

FIGURE 1-2

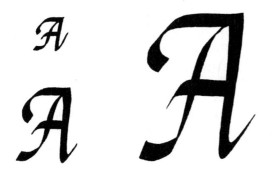

FIGURE 1-3

helps prevent clogging. Dried ink encrusts the point and must be scrubbed off.

Yet some calligraphers love dip pens. They consider the old-fashioned process a satisfying activity which fulfills a psychological need. They also argue quite convincingly that the quality of writing produced by these pens excels all others.

**Fiber Point Pens**

Fiber point calligraphy pens (synonyms: felt tipped pens and markers) are convenient, inexpensive, and portable; you can take them with you everywhere (Figure 1-5). When they run out of ink just throw them away. Also, felt tipped pens can be cut and used for shadow or scroll pens (see page 12, Figure 1-8). They are available in assorted colors and point sizes. Regretfully, their points do not stay sharp so you lose the ability to produce crisp thin lines.

The quality of calligraphy done with a dip or reservoir pen is superior to work done with a fiber point pen. Normally, you will not use a fiber point pen for a serious project; however, they are great for practicing and everyday writing.

**Reservoir Pens**

Most reservoir calligraphy pens (synonym: fountain calligraphy pens) offer the choice of filling the reservoir with ink yourself or buying prefilled cartridges (see Figure 1-1).

Although filling the reservoir pen is not as messy as a dip pen, have some tissue near by just in case. Using prefilled cartridges is more convenient and enables you to use the pen anytime and anywhere you wish.

It is absolutely essential that you use the ink recommended by the pen's manufacturer. If you use India ink or a brand or a type of ink that is not recommended, you run the risk of ruining your pen.

Since the points in reservoir pens are metal they do not wear down like fiber point pens. Their nibs will yield dramatic thick and thin strokes for years.

Sometimes reservoir pens are "fussy." The ink flow can be erratic, too slow, or can just stop. When this happens, tap the nib gently on a piece of paper or dip just the tip into water; then try writing again. If the difficulty persists clean the pen according to the manufacturer's instructions.

**Optional Points**

The scroll and shadow points are exciting and versatile additions to your supplies. The nib is split, causing the pen to write two lines simultaneously (Figure 1-6). If the lines are of equal width, the point is called a scroll; if

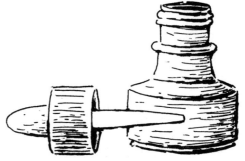

FIGURE 1-4

FIGURE 1-5

*Scroll Shadow*

FIGURE 1-6

one line is wider than the other, it is called a shadow (Figure 1-7). Fiber point pens can be cut and used as a shadow or scroll pen (Figure 1-8).

If you are left-handed, consider writing with an oblique nib. That point is designed specifically for left-handed calligraphers. See pages 38 and 39 which discuss calligraphy for left-handed people.

## PAPER

*F*our factors determine your choice of paper: purpose, surface texture, absorbency, and color. The purpose of your work dictates the paper's quality. Personal preferences determine surface texture, degree of absorbency, and color.

### Purpose

The purpose of your work determines the quality of the paper you select.

For practicing calligraphy and testing design ideas, use a smooth surfaced, inexpensive paper. I recommend typing paper (regular surface or erasable bond) and copier paper. Xerox 4200 DP copier and laser printing paper is my favorite for practice.

Place the unlined paper on top of a guide sheet then tape the papers together, or you may use a clipboard (Figure 1-9). When selecting unlined paper make certain that it is translucent otherwise you will not be able to see your guide sheet.

Another possibility for practice is a lined calligraphy practice pad. In addition to horizontal lines for writing

and spacing, some pads add diagonal lines to help you write with a consistent angle (Figure 1-10).

However when you are working on a "keeper" (i.e., a project that you want to preserve for a long time), use a high quality pH-neutral paper. If the paper is not acid balanced it will yellow with time and unsightly spots may appear. Papers made with cotton or linen fibers (synonym: 100 percent rag) are usually acid balanced.

My favorite quality papers are hot press and cold press bristol board. I also like Pentalic's Paper for Pens, and Hunt's Calligraphy Parchment Paper, but they are not pH neutral.

Understand that I am listing my personal choices; the market offers a large selection of papers. Experimentation will determine your preferences.

Parchment and vellum calligraphy papers are papers with a parchment or vellum finish. If properly sized (see "Absorbency" page 13) they are delightful papers which yield lovely results. They impart a feeling of antiquity to your work.

Parchment is an animal skin, usually a sheep or a goat, which has been prepared for writing. Vellum is a refined parchment prepared from calfskin, lambskin, or kidskin. Although they are both very beautiful, they are also expensive and somewhat difficult to obtain. They are available from "Pendragon" (see page 85).

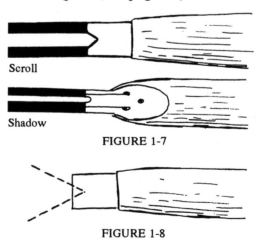

Scroll

Shadow

FIGURE 1-7

FIGURE 1-8

Locate interesting papers by visiting an arts supply store. Stationers and printers also can be good paper sources. Have the clerk show you both inexpensive papers and high quality pH-neutral papers suitable for pen-and-ink calligraphy. In addition to calligraphy paper, ask to see drawing and illustration papers and boards. Some papers are adhered to boards for extra durability.

Ask if samples are available. Never buy a large quantity of paper before thoroughly testing it. Do not risk getting stuck with a stack of unusable paper.

### Surface Texture

Several terms describe surface texture with which you should be familiar: hot press, cold press, laid, and wove.

Hot press paper/board (synonyms: plate and high) is very smooth. This paper is especially recommended for pen-and-ink work.

Cold press paper/board (synonyms: matte, regular, and vellum) is rougher. It works well for pen-and-ink, but is not as smooth as a hot press surface.

Laid paper is paper which is watermarked with parallel lines from the wires on which the pulp was laid during the manufacturing process. If the paper has been properly sized (see "Absorbency") it is suitable for pen-and-ink.

Wove paper is made in a mold in which the wires are so close together that the finished sheets do not show wire marks. If the paper has been properly sized (see "Absorbency" below), it is suitable for pen-and-ink.

Most calligraphers prefer very smooth paper; however, that does not mean you can not be creative and use rough paper.

FIGURE 1-9

Try any kind of paper that you wish. Use artistic license to select the most appropriate paper for each project.

### Absorbency

A paper's absorbency is determined by the amount of sizing in the paper. Sizing, a glue like substance, can be within the paper or applied to the paper's surface.

Avoid unsized paper because it acts like a blotter, absorbing the ink like a paper towel. Rice paper is an example of very absorbent paper. It is impossible to write crisp thin lines on absorbent or unsized paper.

Watercolor paper is not popular with most calligraphers because of its high degree of absorbency. The ink spreads creating fuzzy letters. Still, an interesting effect is possible when writing on rough watercolor paper. The irregularity of the ink flow produces rustic letters which create a special effect (Figure 1-11).

Excessively sized paper presents a different problem. This paper rejects the ink, causing your pen to skip and write erratically. The goal is to use paper that is moderately sized.

Many paper manufacturers produce paper specifically for calligraphy. Some are excellent, others are not. Although they all have a smooth surface, the degree of sizing is not always satisfactory. Experiment with an assortment of papers to discover which ones have the absorbency level that you prefer.

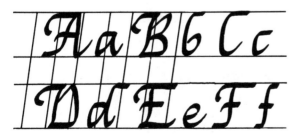

FIGURE 1-10

A paper's absorbency can be modified by rubbing it with a vinyl cleaning pad before writing. I recommend "Magic Pad" by Faber Castell.

### Color

I am conservative when it comes to paper color. I generally select white or off-white paper, because I do not like my calligraphy and paper to compete for attention. However, color can enhance your work. For example, red paper may be the perfect color for a Christmas or Valentine's Day project.

If you are unable to find a particular color, consider modifying the color of existing papers. Write on a quality tracing paper, then place it on top of a bright paper. The tracing paper decreases the intensity of the bright color, creating a softer effect.

## MISCELLANEOUS SUPPLIES

*A*lthough it is not absolutely necessary, it is convenient to have a few additional supplies.

If you do not use ruled paper, tape a guide sheet behind your paper. Or, as previously stated, you may prefer to use a clipboard to anchor your paper.

Sample guide sheets are located on pages 89-93. Photocopy these and select the sheet which matches the point size of your pen.

Three kinds of erasers benefit the calligrapher: the kneaded eraser, the plastic eraser, and the ink eraser. Kneaded and plastic erasers are used to erase pencil marks that are used as guidelines. They do not leave messy crumbs and stain your paper like other erasers. Ink erasers, encased in wood like pencils, can be used to correct minor mistakes. Generally speaking, the thicker (hence stronger) the paper, the more easily you can erase.

Erasing shields are handy, but are not absolutely necessary. To protect the surrounding area, the shield is placed directly over the spot to be erased.

Additional supplies will be needed when creating projects. The following items can be purchased as needed: Number Two pencil, ruler, right-angle triangle, art knife (X-acto is a good brand), technical pen, cutting board (masonite or wood), correction fluid, and spray fixative.

Spray fixative is a useful product for calligraphy projects which use water-soluble ink. After your calligraphy is completely dry, erase the pencil guidelines (if any), then spray the piece according to directions on the can. When the spray dries your project will be waterproof.

Fixative is either glossy or matte. Glossy fixative yields a shiny, reflective surface. When thoroughly dry, matte fixative is imperceptible.

FIGURE 1-11

14

# Chancery Cursive Alphabet

Chancery Cursive is a very popular calligraphy style. It is easy to see why this is true (Figure 2-1). The graceful letters possess such elegant beauty.

There are numerous versions of Chancery Cursive (synonyms: Italic, Humanist Cursive, and Chancery Italic). Most calligraphers develop an individual interpretation of the style (Figure 2-2).

Another reason for its popularity is that Chancery Cursive is very easy to learn. In fact, as you will soon discover, the calligraphy pen does most of the work.

## USING THE PEN

I recommend a medium point nib for initial practice. Fill the pen with ink or insert the cartridge according to the manufacturer's instructions.

Start the ink flow in a reservoir pen by briskly tapping the point on a scrap piece of paper. If necessary, dip the tip of the point into water.

Notice that your calligraphy pen has a chisel point (Figure 2-3). This broad flat point enables the pen to automatically make thick and thin lines. Pressure is not required for line variation.

The only "trick" to learning calligraphy, is to keep your pen's point at a 45° angle to the paper at all times (Figure 2-4). Do not turn the pen in your hand as you write.

If you hold your pen at the proper 45°, you will be able to produce a zig-zag pattern (Figure 2-5). Notice that the right-slanting diagonal is thin and that the left-slanting diagonal is thick. Left-handed calligraphers need to read pages 38 and 39 before proceeding.

Practice making strokes in four different directions: horizontal, vertical, left-slanting diagonal, and right-slanting diagonal. Only the right-slanting diagonal will be a thin stroke; the other strokes will be thick. If you have a thick line instead of a thin line (or vice versa), that means you are not holding the pen at a 45° angle for that particular stroke.

Students frequently turn their pen when making the horizontal stroke. Consequently it is a thin stroke, not a

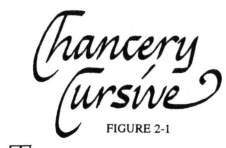

FIGURE 2-1

FIGURE 2-3

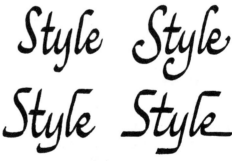

FIGURE 2-2

FIGURE 2-5

FIGURE 2-4

FIGURE 2-6

FIGURE 2-7

FIGURE 2-8

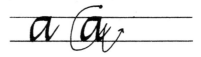

FIGURE 2-9

FIGURE 2-10

FIGURE 2-11

thick one. They write a thin stroke because the pen is at a 180° angle to the paper (Figure 2-6).

Check your angle by drawing a small square on your paper. The diagonal line which bisects the square is 45° (Figure 2-7). The angle of your pen's point to the paper should match the angle of the diagonal line.

When you feel confident making strokes in all directions, combine them into an asterisk (Figure 2-8). The order in which you make the strokes is not important; however, it is essential that you have three thick strokes and one thin stroke. The thin stroke should be the right-slanted diagonal.

## PREPARATION

Now that you understand how the pen works, you can begin writing letters. Before starting make sure that your hands are clean. This will eliminate oily spots on the paper that will repel the ink.

Place your unlined paper on top of the guide sheet, then tape them together at the top or use a clipboard (see page 13, Figure 1-9). Use two spaces for upper

case letters and one space for lower case letters. Leave one line blank between each row of letters (Figure 2-9). Writing large makes learning easier initially and also helps you develop a keen eye for judging proportion and style.

The spacing used in calligraphy practice pads varies considerably. Almost all of them have a sample on the cover or inside the pad which illustrates correct spacing. Some include diagonal lines to help you develop a consistent slant.

Date and keep your practice sheets. They will help you evaluate your progress and pinpoint weak areas needing additional practice. You will be surprised how fast you will progress.

Sit at a table in a comfortable chair. If you are right handed you might like to slant your paper to the left. If you are left handed you might like to slant your paper to the right.

## FIRST LETTERS

Each letter is made of strokes which are written in a particular sequence. Fortunately, many of the strokes are often repeated.

16

Look at the Chancery "A", then observe how it is built using a sequence of strokes (Figure 2-10).

For now duplicate the strokes as much like the example as possible. Your current goal is to learn technique and control. Later you will be encouraged to express your creativity when forming the letter.

Use my sequence of strokes or vary it if you prefer. It is all right to change the sequence of strokes; however, you must memorize the sequence and use it each time you make that letter. Using the same sequence for each letter ensures that all letters have the same shape and proportion. Consistency is a critical factor in creating beautiful calligraphy.

Take your time when you write; write each stroke with care. Pay attention to the shape of the letter that you are creating. Also, if you develop good habits now, you eliminate the need to unlearn bad habits later.

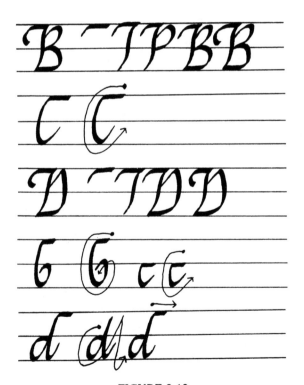

FIGURE 2-12

# Slanted Straight

FIGURE 2-13

Learn lower case letters in conjunction with the upper case letters. This enables you to write words immediately. Lower case letters are usually made with only one continuous stroke. Practice the lower case "a" using a fluid motion (Figure 2-11).

Many people grip their pen too tightly when first learning calligraphy. If you catch yourself feeling tense take a break. Relax by shaking your hand. Try swinging your arm. These exercises are effective ways to relieve tension.

Now, practice letters B-D, upper and lower case, as demonstrated in Figure 2-12.

## SLANT

Notice that my letters slant at a consistent angle. Your letters may slant more or less than mine. There is not one correct slant; degree of slant is a matter of personal taste and style. You may even decide you like to write vertically without a slant; that is perfectly acceptable (Figure 2-13).

Check the consistency of your slant by looking at the reverse side of your paper by holding it up to a light. This trick eliminates the tendency to read the writing rather than analyze the slant.

## JOINS

Chancery Cursive is usually written joined. Joining the letters is practical because it allows you to write

faster and creates a fluid, free-flowing appearance.

Write the following words, joining the letters together (Figure 2-14).

Note that all letters are not joined. A letter is likely to be joined to the letter that follows it if the letter ends in an upward stroke.

## SIZE

As you write strive to make all the upper case letters about the same size. Exceptions to this are the "M" and "W" which will be slightly larger and the "I" which will be smaller (Figure 2-15).

The lower case letters should be the same size, too. Exceptions are the "m"

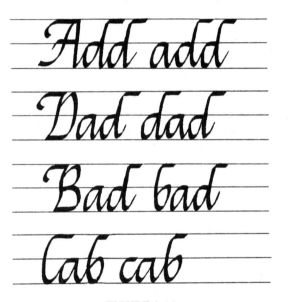

FIGURE 2-14

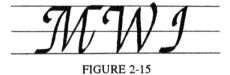

FIGURE 2-15

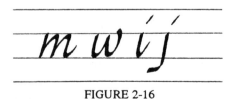

FIGURE 2-16

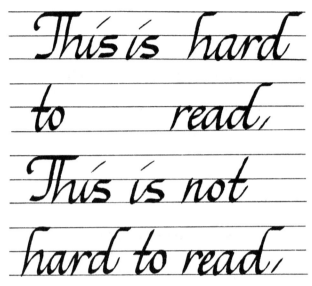

FIGURE 2-17

This is hard to read. This is not hard to read.

FIGURE 2-18

and "w" which will be slightly larger and the "i" and "j" which will be smaller (Figure 2-16).

## SPACING

Notice that the width of a lower case "a" is the amount of space between two words (Figure 2-17). Calligraphy and other types of writing are harder to read when words are spaced more than the width of "a" apart. The tendency to read one word at a time reduces your reading speed and can be confusing; "a" word spacing diminishes this tendency (Figure 2-18). Although other spacing variations are possible, this is considered the most legible. Concentrate on achieving "a" spacing now.

Notice that the letter spacing (the space between the letters within the word) is visually consistent. The amount of space between each letter is not always the same, but it appears the same. If the letter has an irregular shape its spacing is visually adjusted.

Practice writing the letters in Figure 2-19. When you feel confident write words using all the letters that you have learned thus far (Figure 2-20).

I prefer to make my descenders a bit shorter than the ascenders so that I do not have letter collisions (Figure 2-21).

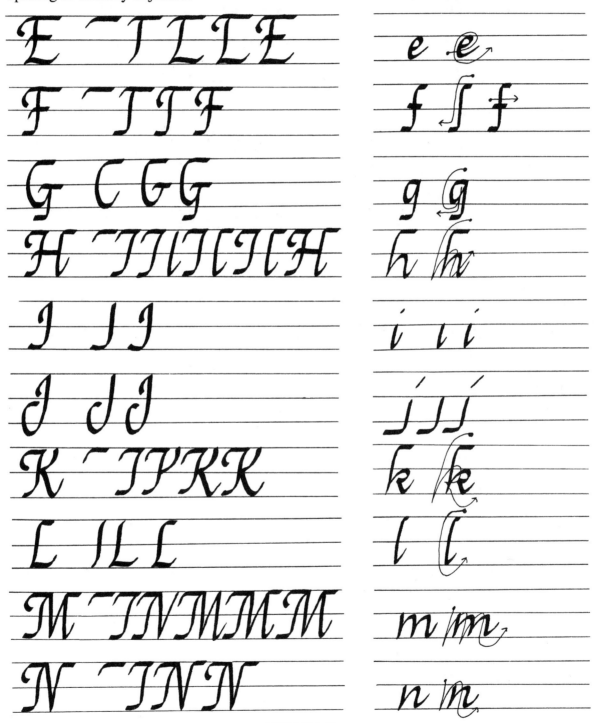

FIGURE 2-19

Another prevention is to write upper case letters and ascenders a little shorter then the descenders. See which you prefer (Figure 2-22).

The remaining letters of the alphabet are less intimidating now that you are gaining experience (Figures 2-23 and 2-24).

*Bambi Jim Bonnie Dina*
*Hal Ann Bill Abe Lee*
*Dick Jack and Jill*
*I baked a cake,*

FIGURE 2-20

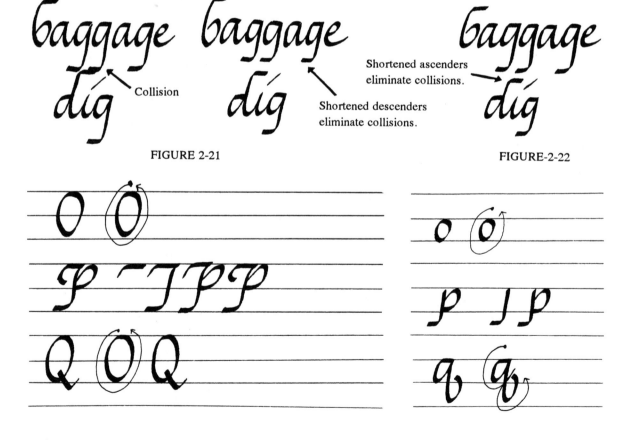

FIGURE 2-21

Collision

Shortened descenders eliminate collisions.

Shortened ascenders eliminate collisions.

FIGURE-2-22

FIGURE-2-23

20

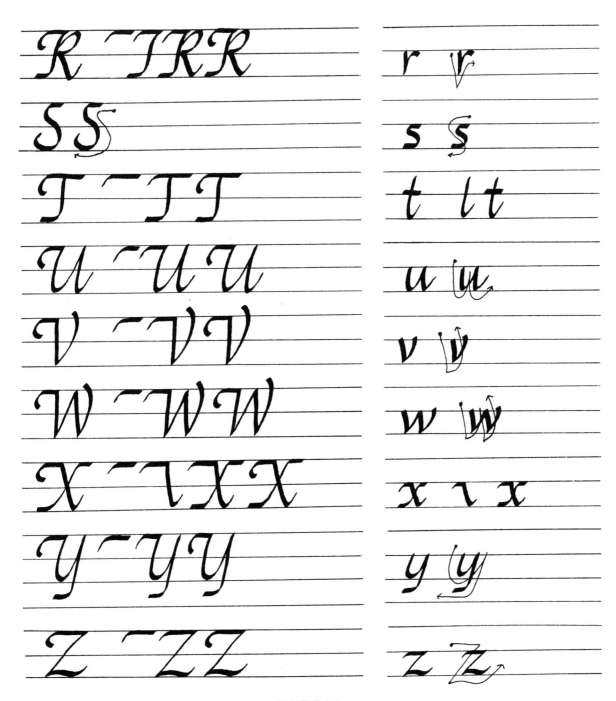

FIGURE-2-24

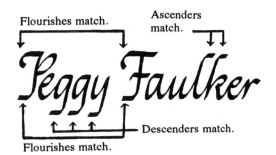

Flourishes match. Ascenders match. Descenders match. Flourishes match.

FIGURE-2-25

*The quick brown fox jumps over the lazy dog,*

FIGURE 2-26

## STYLE

Develop an elegant calligraphy style by being as consistent as possible. All the letters should have a unified harmonious appearance. This means that all letters are the same size, like letters appear the same, proportion and shape are consistent, ascenders and descenders match, and flourishes are identical (Figure 2-25).

## ALPHABET SENTENCE

The sentence in Figure 2-26 contains all the letters of the alphabet. Test your skill by writing the sentence.

## NUMBERS

Numbers, like lower case letters, are usually formed with one continuous stroke (Figure 2-27). Use an "O" for a zero. Some calligraphers prefer to make their numbers slightly smaller than the upper case letters (Figure 2-28). Interesting variations, particularly appropriate for zip codes, are possible by dropping part of the number below the line (Figure 2-29).

## SYMBOLS

Be as consistent with your symbols as you are with your letters (Figure 2-30).

*1 2 3 4 5 6 7 8 9*

*1 2 3 4 5 6 7 8 9*

FIGURE 2-27

*213 Pine Ridge*

*213 Pine Ridge*

FIGURE 2-28

*Ajo, Az, 85321*

*Fry, Ga, 37317*

*Ada, Oh, 45810*

FIGURE 2-29

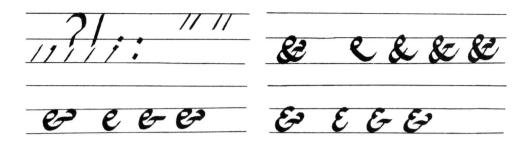

FIGURE 2-30

# ABCDEFGHIJKLMNO PQRSTUVWXYZ abcdefghijklmnopqrstu vwxyz

FIGURE 2-31. Chancery Cursive Alphabet

## PRACTICE

Practice, practice, practice. If you devote a minimum of fifteen to thirty minutes a day to your calligraphy, you will be amazed how much progress you will make. A small investment of time will pay rich rewards.

The most effective way to insure success is to establish a routine. Set aside a specific amount of time everyday at a particular time of day. Make calligraphy a habit.

Practice is more interesting and more practical if you write words, sentences, quotes, copy poems, or write a letter to a friend. Writing individual letters is boring and discourages practice. It also encourages poor spacing habits.

After writing your practice words, sentences, etc., read the "Critique Guidelines" (see page 24, Figure 2-32). Evaluate your style--the overall appearance of your calligraphy, spacing, slant, joins, and readability. Develop a critical eye regarding your work. You can become your best critic.

Your objective is to write like letters as identical in appearance as possible. However, you are a human, not a machine. The precise letters produced by computer printers and typesetting machines are dull and cold. The slight variations of form in hand-written letters are part of calligraphy's charm. We respond with greater warmth and interest to personal handwriting than to mechanically produced lettering (Figure 2-31).

Challenge yourself by reaching for perfection; however, be patient, remember that you are just beginning and it takes time to do anything really well. You would not expect to play in a tennis tournament after several lessons. Be just as realistic regarding your calligraphy. Expertise comes with practice.

# CRITIQUE GUIDELINES

**STYLE**

- All letters have a unified harmonious appearance.
- All letters are the same size.
- Like letters appear the same.
- Proportion and shape are consistent.
- Ascenders and descenders match.
- Flourishes match.

**SPACING**

- Letter spacing is consistent and proportional.
- Word spacing is consistent, using the "a" guide.
- Line spacing is consistent and proportional.

**SLANT**

- All letters slant at the same angle.

**JOINS**

- Smooth joins of strokes within letters.
- Smooth joins between letters within words.

**READABILITY**

- Easy to read.

FIGURE 2-32

24

# Personal Alphabet

The purpose of initially copying my calligraphy is to learn technique, not to blindly reproduce it forever. I encourage you to create a personal interpretation of my style by modifying the letters.

Calligraphy is a very expressive art form because everyone has distinct handwriting. If you need further convincing, remember that a signature is so individual that it is recognized as a form of legal identification.

Style comes naturally. As you have already noticed, no matter how hard you tried to duplicate my calligraphy, some differences consistently occurred. That was your individuality asserting itself. Some variations are worth developing and encouraging, but others should be discarded because they make your work look inconsistent. A discussion of style characteristics will pinpoint your particular tendencies.

## STYLE CHARACTERISTICS

Style is defined as a particular manner of visual expression. Calligraphic style is determined by these characteristics: form, proportion, weight, and letter slant.

The form of a letter refers to its shape. Some calligraphers use very rounded shapes for their letters; others use more angular shapes (Figure 3-1). There is not a right or wrong form. However, some shapes are more legible and more pleasing than others because of their proportions.

Calligraphy can also be condensed or extended (Figure 3-2). Condensed and extended calligraphy is useful for artistic purposes,

emphasis, and variation. However, it is not as readable as normal calligraphy. Consider using it for titles, but avoid in long paragraphs of text as, for example in a letter.

Proportion refers to how parts of letters are put together. Letters have three basic parts: main body, ascenders, and descenders (Figure 3-3). Your style determines if one part of the letter is emphasized more than another, or if all are given equal treatment. Once again, there is not one set of proportions that is correct. Just like the human body, the possibilities for beautiful proportions are infinite.

FIGURE 3-1

FIGURE 3-2

FIGURE 3-3

Experiment with letters by changing their proportions. Increasing the length of the descenders and/or ascenders dramatically changes a letter's proportions (Figure 3-4). Likewise, vary the size of the main body of the letter (Figure 3-5).

The weight of a letter or writing refers to how "heavy" or "light" it visually appears. Letters made with predominantly thick strokes are considered heavy in appearance (Figure 3-6). Tight spacing makes the letters look even heavier (Figure 3-7). Light letters are made with thin strokes predominating (Figure 3-8). Wider spacing increases the feeling of lightness (Figure 3-9).

The slant of your writing is almost an automatic response. Since you already write cursive, most likely the slant of your everyday handwriting will be the slant of your calligraphy. However, change the slant if you think it would improve the appearance of your calligraphy. Different slants, including no slant at all, give calligraphy a distinct feeling. Which look do you like the best (Figure 3-10)?

Although until now I have adamantly stressed to always keep your pen at a 45° angle, you can now vary that if you wish. Writing at 180° or another angle will drastically change your style (Figure 3-11). The important key to remember is--you must be consistent with whatever angle you decide to use.

Each style creates a different visual impression. So, as you develop your style, keep in mind the kind of impression you wish to make with your calligraphy. Do you want a formal or

FIGURE 3-4

FIGURE 3-5

FIGURE 3-6

FIGURE 3-7

26

informal look (Figure 3-12)? Is legibility your primary objective or do you want to be more creative and free (Figure 3-13)? Ornate letters suit some calligraphers while others prefer a plain letter (Figure 3-14).

Keep in mind that the ultimate goal for your personal alphabet is consistency and visual harmony. See the "Critique Guidelines" on page 24 for specific information regarding how to analyze your style.

*Calligraphy*

FIGURE 3-8

*Calligraphy*

FIGURE 3-9

*Calligraphy*

*Calligraphy*

*Calligraphy*

FIGURE 3-10

*Calligraphy*

FIGURE 3-11

*Calligraphy*

*Calligraphy*

FIGURE 3-12

*Calligraphy*

*Calligraphy*

FIGURE 3-13

*Calligraphy*

*Calligraphy*

FIGURE 3-14

## LIGATURES AND DOUBLE LETTERS

Creating ligatures and fancy double letters requires more skill than writing basic letters, that is why they have not been discussed before. Adding ligatures and using fancy double letters are a great way to individualize your work; however, use good taste. Do not let them overpower the letter (Figure 3-15).

Ligatures are decorative connecting strokes between two letters (Figure 3-16). Like joins, it is not feasible to have ligatures for every letter combination. Common ones are shown in Figure 3-17.

I prefer to use downward strokes when making ligatures.

Double letters can be written identically or one letter can be varied. Study the examples shown, then invent your own combinations (Figure 3-18).

## FLOURISHES

Flourishes are fancy ribbon-like decorations used to enhance and embellish your work (Figure 3-19). Always remember that the quality of your calligraphy is based on the beauty of the basic letters, not on superficial additions. No amount of flourishing will substitute for poorly proportioned or sloppily formed letters.

*stopped*

Overpowering Ligatures
and Double Letters

FIGURE 3-15

*art carp*

*should spot*

*skate last*

*that chaste*

*act rack*

FIGURE 3-16

*rt rp*

*sh sp sk st*

*th t k*

FIGURE 3-17

*egg egg egg*

Double Descenders

*call call call*

Double Ascenders

*officer*

FIGURE 3-18

FIGURE 3-19

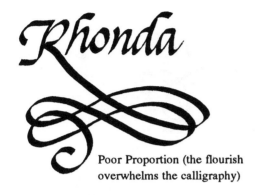

Poor Proportion (the flourish
overwhelms the calligraphy)

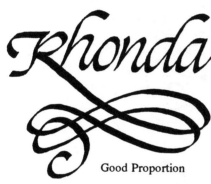

Good Proportion

FIGURE 3-20

Symmetrical Balance

Asymmetrical Balance

FIGURE 3-21

FIGURE 3-22

Note that in the examples of flourished letters, the basic letter does not change. Flourishes are typically created by extending a stroke of the letter.

Good proportion and balance are essential for flourishes. Proportion refers to size relationships. For flourishes it means how the size of the basic letter relates to the size of the flourish (Figure 3-20). Balance refers to the visual weight of the flourished letter. The flourish can be symmetrical or asymmetrical (Figure 3-21). Regardless of what type of balance you prefer, the end result must appear visually balanced.

The purpose of flourishing is decoration; legibility is secondary. Nevertheless, use discretion when designing flourishes. Strive for a sense of refinement, avoid gaudiness.

Technical pens are excellent for adding wispy additions (Figure 3-22). The thin precise lines provide contrast and visual interest.

Flourishes appear very complicated at first. Study the flow, then trace the example to get a feel for the form (Figure 3-23). Continue to keep your pen at 45°, but turn the paper if you wish to get different effects.

The wrists and fingers are used when writing calligraphy. Generally, flourishes are written with the entire arm using one continuous flowing motion. However, some calligraphers prefer to break a flourish down into different parts. Use the method that works for you.

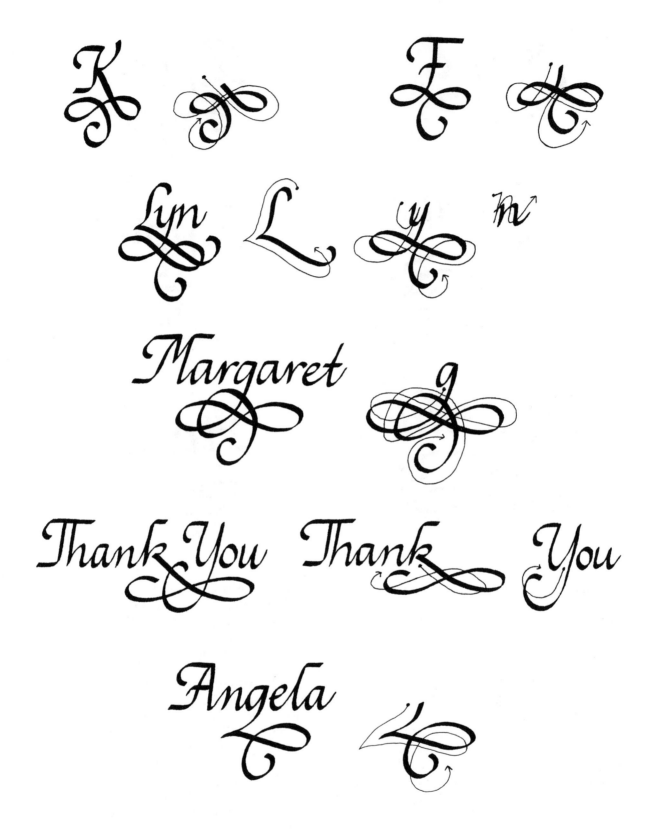

FIGURE 3-23

# *Decorations and Embellishments*

*C*alligraphy is often embellished with decorative elements. Typical design features include: initials and decorative letters, illustrations, clip art, line finishings, borders, scrollwork, and pictorial calligraphy.

There are numerous ways to dress-up your work; however, keep in mind that the true beauty of a project is based on the quality of the calligraphy, not on the fancy additions. Embellishments do not substitute for poorly executed letters.

## INITIALS AND DECORATIVE LETTERS

*E*nhancing your calligraphy with initials or decorative letters is easy and effective.

Whether your initials are elaborate or simple, always experiment with size and placement through preliminary designs and rough sketches (Figure 4-1).

If the piece has more than one paragraph, consider using an initial at the beginning of each paragraph (see page 42, Figure 7-1). Write the initials in the same style as the body of your text; just make them larger and bolder by using a broader point nib.

If you wish, you can modify an existing style (Figure 4-2) or design a letter from your imagination (Figure 4-3). Draw with a calligraphy pen or switch to a different type. I prefer a #00 Rapidograph technical pen for drawn letters (Figure 4-4). Scrollpoint pens make very pretty initials (Figure 4-5).

FIGURE 4-1

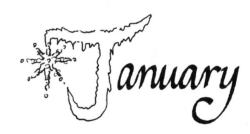

FIGURE 4-3

Clip Art          My Version

FIGURE 4-2

FIGURE 4-4

FIGURE 4-5

An initial is considered a decorative letter when it is heavily ornamented (Figure 4-6). In fact, it almost looks more like an illustration than a letter. Decorative letters are very dominant; therefore, use them with moderation.

Adding flowers, leaves, and other plant forms to a letter creates a naturalistic effect. These letters are intriguing; they actually appear to be growing on your paper (Figure 4-7).

Elegant initials can be created by adding simple flourishes (Figure 4-8). A letter that makes extensive use of flourishes is called a swash initial (Figure 4-9).

Drawing a box around the letter is a conservative yet effective embellishment (Figure 4-10). Fill in with color or a pattern, if you desire (Figure 4-11).

Using a contrasting color or outlining is also a captivating decoration (Fig. 4-12).

## ILLUSTRATIONS

Illustration and calligraphy are very compatible. A well chosen drawing establishes a mood, setting the stage for the viewer. If you correctly select an illustration you will pique the viewer's interest to read your work. Attracting the viewer to your work is important; illustrations can make your calligraphy more effective.

The medium you use to make the illustration should be compatible with the paper that you select for calligraphy. Pen-and-ink, pencil, charcoal, pastel, and colored pencil are good choices for most papers. Still, you should always test the medium on the selected paper before you start the final product.

If you want to use water-based media such as watercolor, tempera, designer's colors, thinned acrylic, or dyes, select sturdy, thick paper that can withstand water washes without excessive buckling.

Before purchasing color media, check the container to assess the product's lightfastness. Avoid the disappointing experience of investing time and effort into a project only to have the beautiful colors fade in a short time. Markers are not recommended for drawings, because they are not lightfast. They will fade when exposed to bright light and with time.

Some calligraphers advocate first completing the calligraphy, then adding the illustration. You may prefer to reverse the procedure.

If you plan to reproduce your work, keep in mind that some media can be printed less expensively than others. Pen-and-ink drawings are the least expensive to reproduce. Pencil, charcoal, diluted black ink wash, or black watercolor wash requires the additional (although nominal) expense

FIGURE 4-6

FIGURE 4-7

FIGURE 4-8

FIGURE 4-9

FIGURE 4-10

FIGURE 4-11

FIGURE 4-12

FIGURE 4-13                    FIGURE 4-14          FIGURE 4-15

of having a halftone prepared by the printer.

A halftone is an image which represents grays (i.e., shadows) by a dot pattern.

Complex artwork using color media such as colored pencil, pastel, watercolor, dyes, tempera, and acrylic requires camera-made color separations. This method of color printing is called four-color process. It is an expensive procedure which is done by commercial printers.

You can prepare color separations for simple color designs. See books on art production for instructions. If the procedure sounds too complicated have the printer make camera-made color separations.

If you are doing a small number of reproductions or are on a budget, a less expensive way to have full color is to have the drawing and calligraphy printed in one color--probably black or brown. Then you can hand color each print with watercolor or colored pencils.

Color photocopies are an alternative, but the quality is not as good as four-process color which the commercial printer provides.

## CLIP ART

Even if you do not draw you can still add illustrations to your calligraphy. Clip art can be an excellent substitute for original art. This art is copyright free allowing you to use it without special permission.

An incredible variety of drawings and designs are available. Although book

stores and art supply stores sell clip art books, obtain catalogs for a comprehensive selection. Page 85 lists sources for these catalogs.

Once you find an illustration, initial, etc., that you wish to use, cut it out and paste in position on the paper using rubber cement or spray adhesive. It is that simple! Cut-and-pasted clip art is best suited for work to be reproduced.

Clip art can also be traced. When you are creating a one-of-a-kind project and want to use artwork, trace the clip art on your paper in position.

## LINE FINISHINGS

Line finishings add an elegant touch to your calligraphy. These subtle additions, when well chosen, enhance the expressive power of your work. By filling excessive white space with line finishings you can give the project a better sense of balance and avoid a spotty appearance (Figure 4-13).

A line finishing can be placed at the end of every sentence (Figure 4-14) or at the end of a paragraph (Figure 4-15). I prefer a single symbol if using them at the end of every sentence and a repeat design for the end of each paragraph.

Make the line finishing with a calligraphy pen or switch to another type. I frequently use a #00 Rapidograph technical pen for line finishings.

Experiment with your pen to create different designs. Prepare precise designs by using graph paper as a guide sheet (Figure 4-16).

Line endings can also be used as borders.

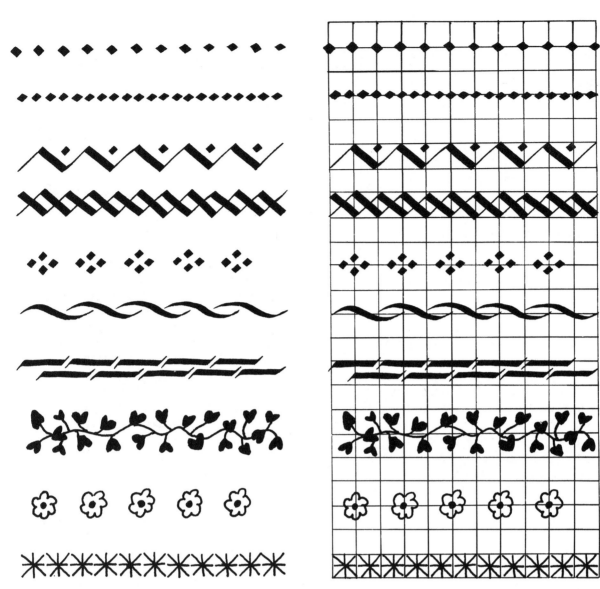

FIGURE 4-16

## BORDERS

*B*orders and cartouches (synonym: small frame) act like frames, setting your work apart from its surroundings and focusing on your calligraphy. In effect a border is like a window inviting the viewer to look through at your work.

Borders can be plain (see page 35, Figure 4-22) or elaborate (Figure 4-17).

Like other design elements, borders are very dominant, do not be over zealous when adding them. For example, avoid using a bold border with delicate calligraphy (Figure 4-18).

The character of the border should match the spirit of the piece (Figure 4-19 and Figure 4-20). Imagine how those illustrations would appear if the their borders were switched.

Clip art offers a multitude of border possibilities. The examples in Figures 4-17 through Figure 4-20 use clip art borders.

A mat is the easiest border. Select a color and texture in keeping with the character and color scheme of your work. Besides traditional matboards, consider using ribbon or lace (Figure 4-21). Adhere the border to your paper with two-sided tape.

Generally speaking, formal projects look best with a dignified French mat (Figure 4-22). Using a ruler, draw one or two rectangles around the calligraphy.

FIGURE 4-17

The bold border overwhelms the delicate calligraphy.

FIGURE 4-18

FIGURE 4-19

FIGURE 4-20

FIGURE 4-21

FIGURE 4-22

FIGURE 4-23

It is important to keep the size of the border in proportion to the size of the project. Observe the poor effect demonstrated in Figure 4-18.

A border does not have to completely frame your work. Try using a border on one, two, or three sides of your piece (Figure 4-23).

Your border, mat (if used), and frame should not clash. Choose a mat and frame that compliments your border and calligraphy.

Excellent idea sources for borders include art books exhibiting various styles: Celtic, Renaissance, Medieval, Arts and Crafts movement, Art Deco, and Art Noveau. Also, take a closer look at the molding on building interiors, trim on building exteriors, wallpapers, and textile designs (clothing, upholstery and drapery fabrics, and carpets).

## SCROLLWORK AND PICTORIAL CALLIGRAPHY

Scrollwork is an ornamentation used with calligraphy which makes extensive use of scrolls, i.e., spiral designs. Pictorial calligraphy is a drawing (usually of an animal or bird) which is drawn with a calligraphy pen.

Scrollwork and pictorial calligraphy are often combined.

Today the most common use of scrollwork is seen on diplomas; however, in previous centuries it was used more frequently (Figure 4-24).

Although detailed instructions regarding scrollwork and pictorial calligraphy are beyond the scope of this book, an introduction is included because both are considered traditional decorations.

The majority of scrollwork and pictorial calligraphy is done with a copperplate point (Figure 4-25). Unlike the rigid chisel point which makes thick and thin strokes automatically, the flexible copperplate point achieves line variation when pressure is applied. The copperplate point is also used to write Copperplate calligraphy (synonym: English Roundhand) (Figure 4-26).

If you are interested in scrollwork and pictorial calligraphy see page 96 for a list of inspiring examples. I particularly

FIGURE 4-24

recommend ORNATE PICTORIAL CALLIGRAPHY by E. A. Lupfer.

Although traditional scrollwork is virtually impossible to achieve with a chisel point pen, creative pictorial calligraphy is possible.

Free-form drawings made with your chisel point pen produce exciting pictorial calligraphy (Figure 4-27). Draw a faint pencil outline, then build the animal stroke by stroke just like a letter.

FIGURE 4-25

*Copperplate Calligraphy*

FIGURE 4-26

FIGURE 4-27

# Left-Handed Calligraphers

Chancery Cursive was invented by right-handed people. As a result, left-handed people usually become very frustrated when first introduced to calligraphy.

The problem is often solved by purchasing an oblique pen point (Figure 5-1). The oblique point enables left-handed persons to write more easily, because it allows the pen to be held at the correct angle (Figure 5-2).

If you are left-handed, and write with the chisel point pen designed for a right-handed person, you will not be able to write with the point at an 45° angle to the paper. In fact, you will most probably write at 135° to the paper, resulting in thin strokes exactly opposite directionally (Figure 5-3). Since the thin strokes are reversed, the letters will look entirely different (Figure 5-4).

As a teacher, it has been my experience that left-handed people have diverse writing styles. Experiment with the oblique point in order to determine the correct angle. Practice making the diagonal strokes until you can get a thick left-slanted diagonal and a thin right-slanted diagonal without turning your pen. When you can make all the strokes match the asterisk on page 16, you have discovered the correct angle for holding the pen.

Whereas the right-handed calligrapher generally slants their paper to the left when writing, the left-handed calligrapher may prefer to slant their paper to the right. Likewise, most right-handed calligraphers make pen strokes from left

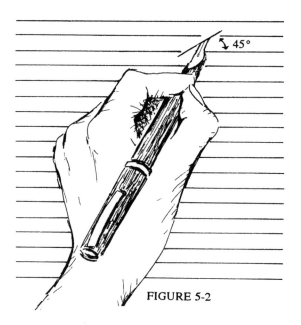

FIGURE 5-2

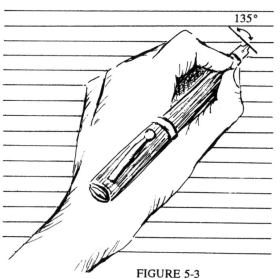

FIGURE 5-3

▼ FIGURE 5-1

FIGURE 5-4 ▲

38

to right, writing away from the body; left-handed people may do just the opposite--making pen strokes from right to left and writing toward their body.

If you write upside-down (with a hook) try writing with both the chisel point and the left-hander's oblique point (Figure 5-5). Use whichever point yields the best results and feels the most comfortable.

Some left-handed calligraphers write with a chisel point and turn their paper perpendicular to their bodies and their hand (Figure 5-6). Perhaps that will work for you; give it a try to see if it is comfortable.

For the left-handed calligrapher there is not one correct way to hold the pen as there is for the right-handed calligrapher. Experimentation will help you determine the correct angle which is the 45° equivalent of the right-handed calligrapher.

Do not get discouraged because there are many excellent left-handed calligraphers. Perhaps the most famous is Leonardo di Vinci. I would say you are in good company!

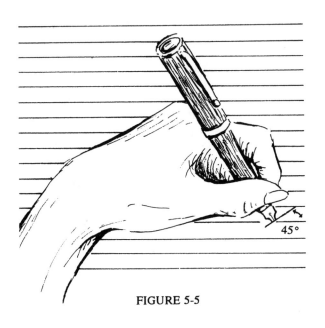

FIGURE 5-5

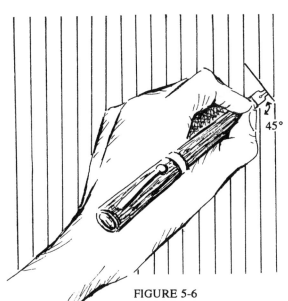

FIGURE 5-6

# Making Corrections

Regardless of how experienced you are, mistakes are certain to occur. Sometimes they are correctable, other times they are not.

If you are working on an important project, many mistakes can be avoided by first making a pencil draft of your design. Experiment with calligraphy placement, margin widths, and various line spacing. A preliminary pencil layout is much easier to erase than ink.

Although many mistakes can be avoided by using the above suggestions, mistakes will occur nevertheless. If you make an error, correct it by using the following methods: erasing, using correction fluid, pasting in a correction, and starting over.

## ERASING

Erasing is not done until the ink is completely dry. Using a typing eraser (pencilform), erase first in one direction, then change directions. So as not to disturb the surrounding area, place an erasing shield directly over the spot to be erased. Shields are handy to use, but are not absolutely necessary.

Use paper that will permit erasing. Generally, the smoother and sturdier the paper, the more erasing it can handle. Papers that erase particularly well are hot press illustration board and hot press bristol board, as both have very smooth surfaces. Cold press illustration board and cold press bristol board can also handle erasing, but not as well as hot press surfaces.

Incidentally, bristol board comes in one, two, three, or four-ply paper. The thicker the ply, the sturdier the paper, increasing not only its erasing endurance but its cost.

Erasing damages paper. It disturbs the surface by making it rougher and more porous. When added to erased areas

Mary had a little lamb,

Mary had a little lamb,

FIGURE 6-1

Mary had little lamb,

Mary had a little lamb,

FIGURE 6-2

ink spreads, making the lines look fuzzy. To minimize this problem, lightly cover the area with pencil marks. Smear the marks with a clean finger, then add ink. Erase the pencil smear when the ink is completely dry. Another method is to lay a thin sheet of paper over the erased section, then burnish. The cover sheet will eliminate a shine on your good paper. Writing corrections on a burnished surface appears less obtrusive.

Test papers for their erasability before starting a project. Make marks, then erase. How well do they stand up to the job? How easy it is to write on the erased area?

Electric erasers are a luxury tool. Although expensive, their efficiency makes them a worthwhile investment for the committed calligrapher. They can speedily erase large areas. However, care must be taken when using an electric eraser. Since they work quickly, they can wear a hole through your paper if you are not careful.

Sometimes an erased area is not noticeable, but other times, it is an eyesore. You be the judge. If the erased area is unsightly you may prefer to do your project over.

Nonglare glass can camouflage damage caused by erasing and reworking if your project is to be framed. Place a piece of nonglare glass over your project, then hold your work vertically to test the results.

## CORRECTION FLUID

*U*sing correction fluid is faster than erasing. The error is not gone, it is just camouflaged. Corrections for one letter are acceptable, but for larger areas this method creates poor results (exception: mistakes for works to be reproduced correct very well using this method).

When the ink is completely dry, lightly brush correction fluid over the mistake. Let the correction fluid dry completely. Rewrite your letter or word. If the ink beads up, let the ink dry. Draw the letter with a technical pen, filling in the broad areas.

Designer's White and Pro White are paints which can also be used to make corrections. Apply these products using a small watercolor brush. Writing over the dry paint is easier than writing over correction fluid.

Do not be overly concerned if your project has a mistake or two. Calligraphy does not have to be absolutely perfect to be beautiful.

## PASTING IN A CORRECTION

*C*orrecting mistakes for projects which will be reproduced is usually a very simple matter.

Brush correction fluid over the mistake and let it dry completely. Write the word(s) on another sheet of paper, then paste it in position over the error on your original (Figure 6-1). If necessary, an entire line can be corrected using this method (Figure 6-2).

This procedure works great if you left out a letter, misspelled a word, transposed words, repeated words, or made a blunder when writing a letter.

Run a test photocopy before having your project reproduced. If cut edges make shadows that show on the photocopy, eliminate them by brushing with correction fluid.

## STARTING OVER

*I*f your mistake looks unsightly after correcting, then starting over is, perhaps, the best alternative.

Are you tired or very tense? If so, put your project aside and tackle it again when you are refreshed.

Dear Mother,

Our weather has finally gotten warmer.
After all the snow we had last month
I am definitely ready for some sunshine.

Did Mary Anne call you about the
family reunion? She wants to schedule it
for May. Barbara and I both prefer
June.

Frank's team made the basketball
finals. He's so excited and proud. We
are, too.

Let me know about Sandra's test results.
We are very concerned about her.

Love, Kathy

FIGURE 7-1

# Correspondence

Correspondence is the most common use for calligraphy. However, if you use calligraphy for your correspondence it will definitely not be common!

Letters to family and friends are a special treat when written in calligraphy (Figure 7-1). Make your letters even more unique by designing your stationery (Figure 7-2).

You can make notecards, too. Create cards for everyday, special events, and holidays (Figure 7-3).

I write all of my personal correspondence in calligraphy for pleasure and for perfecting my skill. Knowing that people enjoy receiving my work is a good incentive to continue the practice.

Writing your correspondence in calligraphy is an excellent habit. Practicing with a specific purpose will improve your skills more quickly than mindless exercises. It is also more entertaining.

FIGURE 7-2

▼ FIGURE 7-3 ▲

## STATIONERY

*P*ersonalized stationery is a pleasure to use and to receive. Delight your friends by using unique stationery.

1. Select size. Determine size of stationery after obtaining envelopes. Visit printers and stationers to locate samples. Remember that the sheet has to fit the envelope; so, select sheets having a width at least ¼-inch smaller than the envelopes. I like to use 8½-by-11-inch sheets because they fit standard #10 envelopes (4 1/8-by-9½-inch). This is both a convenient and economical choice.

2. Design stationery. Begin by doodling. Write your name numerous times, playing with flourishes, connecting letters, etc. Use upper case and lower case or all upper case or all lower case. Experiment with designs that use your first name;

FIGURE 7-4

FIGURE 7-5

first and last name; first, middle, and last name; and name and address (Figure 7-4). Regardless of your design preference, think of what you are writing as one unit.

3. Design placement. Consider the placement of your unit on the page. Cut out your unit and move it around the paper, testing which position looks best. For example, you could place it at center top, left top, down the left or right side, or across the bottom (Figure 7-5). Also consider changing the size of your unit. Would making it larger or smaller improve the design (Figure 7-6)? How would the design look if it was repeated (Figure 7-7)?

4. Individual originals. To make individual designs, use rubber cement or spray adhesive to glue your design in position on your reusable stationery

FIGURE 7-6

FIGURE 7-7

1. Select size. Determine size of stationery after obtaining envelopes. Visit printers and stationers to locate samples. Remember that the sheet has to fit the envelope, so select sheets having a width at least ¼-inch smaller than the envelopes.

2. Design monogram. Using one, two, or three letters, experiment with the letters by doodling (Figure 7-8). Use all upper case, upper and lower case or all lower case. The letters can all be the same size, but vary the sizes if it makes a more attractive design. Also, try altering the sequence. For a three initial monogram, try placing your last initial in the center as well as at the end. Determine the sequence based on what makes the most attractive monogram. Try overlapping the letters and writing them in a vertical format. Add symbols or abstract designs if you wish. As evidenced by the examples, there are no rules, let your imagination be your guide.

design sheet. Place a clean sheet over your design sheet. Make light pencil marks to indicate placement of the design. Replace your design sheet with a guide sheet. Write your design. (Your design may not require the use of a guide sheet.) Gently erase the pencil marks when the ink has completely dried.

5. Reproduction. For stationery to be reproduced by a printer or by photocopying, glue your design in position on your stationery design sheet. Before printing or photocopying large quantities, run a test photocopy. If the cut edges make shadows that show on the photocopy, eliminate them with correction fluid. I especially recommend selecting linen finish paper for your stationery.

## MONOGRAMMED STATIONARY

*M*onograms make perfect designs for personalized stationery. The possibilities are infinite.

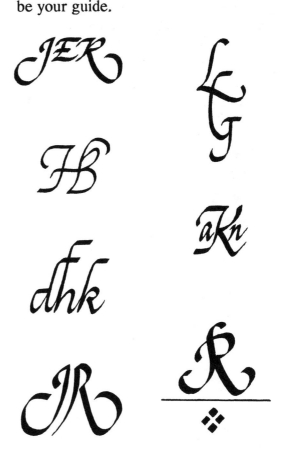

FIGURE 7-8

3. Design placement. Consider the monogram as a unit as you experiment with its placement on the page. Test an assortment of positions (Figure 7-9). Also consider changing the size of the unit. Would enlarging or reducing the unit improve the design (Figure 7-10)?

4. Individual originals. To make individual designs, use rubber cement or spray adhesive to glue your design in position on your reusable stationery design sheet. Place a clean sheet over your design sheet. Make light pencil marks on the clean sheet to indicate the placement of the design. Replace your design sheet with a guide sheet. Write your design. (Your design may not require the use of a guide sheet). Gently erase the pencil marks when the ink has completely dried.

5. Reproduction. For stationery to be reproduced by a printer or by photocopying, glue your design in position on your stationery design sheet. Before printing or photocopying large quantities, run a test photocopy. If the cut edges make shadows that show on the photocopy, eliminate them with correction fluid. I especially recommend selecting linen finish paper for your stationery.

## NOTECARDS

*M*aking your own notecards enables you to be very expressive and to save money.

1. Select size. Determine size after obtaining envelopes. Visit printers and stationers to locate samples. The width and length of the card when folded should be ¼-inch smaller than your envelope (Figure 7-11).

2. Folding notecards.
   A. Determine how the card will be folded. A quarto is folded twice and a folio has one fold (Figure 7-12). If you choose a quarto fold use paper that will fold easily. Test a sample sheet. A folio fold is best when made with thick paper. For a folio fold, I recommend a heavy paper such as cover stock or index stock if you have the cards commercially printed. Cover stock is higher quality paper than index stock, therefore, is more expensive. I also recommend that if you are having reproductions made of a card with a folio fold, have the printer make the fold. Folding by

FIGURE 7-9

FIGURE 7-10

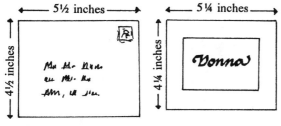

FIGURE 7-11

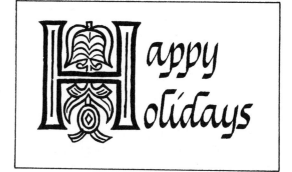

Folio Fold          Quarto Fold

FIGURE 7-12

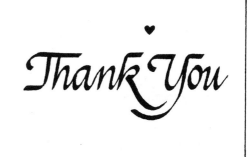

FIGURE 7-13

FIGURE 7-14

hand will not yield a crisp fold because the paper is too thick.

B. Decide where you want to place the folio fold. Do you want it on the left side as in Figure 7-12 or on the top (Figure 7-13)? Make your final decision concerning the fold after completing your design.

3. Test design. Draw a rectangle the same size as the card when folded, then write your greeting to test your idea on the facsimile card (Figure 7-14). Design your greeting by experimentation: use flourishes to join words, add symbols, or vary the sizes of the words. Would a plain or fancy border be appropriate? If done appropriately, a border focuses attention on your message. Would you improve the design if you added an illustration, clip art, or a monogram?

4. Execute design. Using quality paper for a one-of-a-kind card or a sturdy paper for a design to be reproduced, make your personalized notecard.

5. Reproduction. If your design is to be reproduced, run a test photocopy before taking it to the printer. If design elements are pasted in, watch for shadows. Use correction fluid to eliminate shadows.

## POSTCARDS

*R*eceiving a postcard is always a special treat. Increase the recipient's pleasure by sending an original design.

1. Select size. Typical size postcards are 4-by-5 3/4-inches and 4 1/8-by-5 7/8-inches. Do not design a postcard smaller than 3½-by-5-inches; the post office will not deliver it. If your card is larger than 4¼-by-6-inches and/or weighs more than one ounce, you must use a first class stamp, not a postcard stamp.
2. Test design. Draw a rectangle the same size as your finished postcard. Design your greeting by experimentation. Possibilities include the use of borders, clip art, flourishes, and symbols to enhance your greeting (Figure 7-15).
3. Design the back of the card. If you wish, add lines for the address and stamp (Figure 7-16). When you do this there will be an additional printing charge because your postcard now has two sides. For economy, simply draw a line using pen and triangle, separating the address and your message each time you write a card (Figure 7-17).
4. Execute design. Using a fairly thick paper, create your final postcard.
5. Reproduction. For postcard reproduction, run a test photocopy before taking it to the printer. If design elements are pasted in, watch for shadows. Use correction fluid to eliminate shadows. For commercially printed postcards, I especially recommend selecting index stock for your paper.

## FORMAL INVITATIONS/ ANNOUNCEMENTS

*S*pecial events and important announcements assume greater significance when the sender designed the greeting.

FIGURE 7-15

FIGURE 7-16          FIGURE 7-17

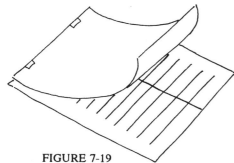

FIGURE 7-18

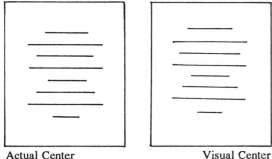

FIGURE 7-19

Actual Center          Visual Center

FIGURE 7-20

FIGURE 7-21

FIGURE 7-22

1. Select size. Determine size of card after obtaining envelopes. Visit printers and stationers to locate samples. The width and length of the card when folded should be 1/4-inch smaller than your envelope (see page 47, Figure 7-11).

2. There are two commonly used methods for creating formally designed invitations and announcements. Use the method that you consider the most appropriate.

**Method A**

(1) Write your invitation/announcement. With ruler, mark the center of each line (Figure 7-18).

(2) Make a rough draft. Mark the vertical center of your guide sheet with a line (Figure 7-19). Place paper over guide sheet. Determine where to place the first line by counting the number of text lines then adding the number of lines necessary for spacing. The center of the invitation should be in the visual center of the paper, not the actual center (Figure 7-20). The visual center is located slightly above the actual center. Place your written sample above the line to be written and use it as a guide to center each line (Figure 7-21). Consider adding a simple border, an ornate border, or scroll letters (see page 50, Figure 7-23). Experiment with many ideas.

(3) Make your final invitation/announcement by recopying the text as discussed in number two. If you are using thick paper use your guide sheet to add light pencil guidelines to your original paper (Figure 7-22). Erase the guidelines when the ink is dry.

(4) If you are having the piece printed, run a test photocopy before having the reproductions made. Eliminate shadows around cut edges with correction fluid.

**Method B**

(1) If you are having the invitation printed, you can prepare the invitation

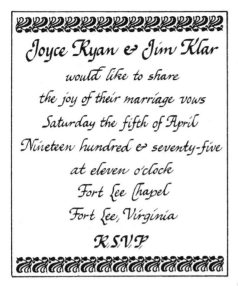

FIGURE 7-23

using this alternative. Write each line of text, then cut out each line. Using rubber cement or spray adhesive, glue in centered position on your final sheet. Add embellishments and/or border (Figure 7-24).

(2) Run a test photocopy before having reproductions made. Eliminate shadows around cut edges with correction fluid.

## INFORMAL INVITATIONS

Personally designed invitations for casual gatherings will create anticipation and excitement. Put your

guests in a party mood right from the beginning.

1. Determine format. In addition to quarto and folio cards (see page 47, Figures 7-12), consider writing your text on an 8½-by-11-inch sheet of paper and folding it into thirds, then securing it with a seal (Figure 7-25). Or, just place it in a #10 envelope. A postcard can be used for an invitation, too. For hand produced work, spray the postcard with fixative to waterproof before mailing.

2. Select size. Determine size of invitation after obtaining envelopes

Printed invitation

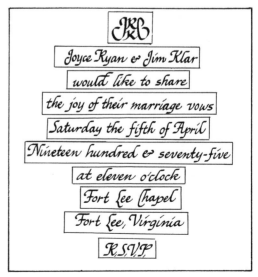

Invitation to be printed

FIGURE 7-24

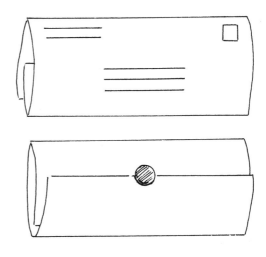

FIGURE 7-25

(if envelopes are to be used). The width and length of the card when folded should be 1/4-inch smaller than your envelope (see page 47, Figure 7-11). Visit a stationer or printer to obtain samples.

3. Design card. Compose the text of your invitation. Do you want to use a greeting and/or illustration on the outside of the card and have the particulars inside? In that case, a form might be appropriate (Figure 7-26). Also, consider your greeting. Would a border, illustration, or symbol be appropriate (Figure 7-27)?

4. Prepare final design. If you are using thick paper use your guide sheet to add guidelines to your original paper (see page 49, Figure 7-22). Erase guidelines after the ink is completely dry.

5. Reproduction. Run a test photocopy before having reproductions made. Eliminate shadows around cut edges with correction fluid.

## ENVELOPES

You can design envelopes to match your stationary or coordinate with the stamp (Figure 7-28). Set the tone

▲ FIGURE 7-27

◄ FIGURE 7-26

FIGURE 7-30

FIGURE 7-28

▲ Poor Placement

Good Placement ▼

FIGURE 7-29

FIGURE 7-31

for what's inside with a logo, clip art, or illustration (Figure 7-29). A straightforward yet elegant design is always in good taste (Figure 7-30).

1. Addressing the envelope. Consider both the return address as well as the recipient address. The post office prefers return addresses on the front of envelopes. However, they will deliver them if they are on the back.

2. Sense of proportion. Be sensitive to the proportion of your envelope in relation to your return address and the recipient address. Size and placement are important (Figure 7-31).

FIGURE 7-32

FIGURE 7-33

FIGURE 7-34

3. Legibility. If you add flourishes, designs, illustrations, borders, etc., make certain that they do not affect the legibility of the addresses.

4. Guide sheet use. Insert guide sheet into envelope before writing (Figure 7-32). Use a smaller spaced guide sheet for the return address.

5. Special touches. Consider using sealing wax and a seal for a very special effect (Figure 7-33). You make a lovely statement either with or without a ribbon (Figure 7-34). These special touches take a minimum of expense and effort, but produce beautiful results.

# *Home*

Calligraphy enables you to create a variety of art for your home. Some projects are utilitarian and practical while others are purely decorative.

Regardless of why you make the projects or their purpose, they are unique personal expressions of your family life. In future years they are certain to become treasured heirlooms which will recall happy memories.

## LABELS

Labels are very useful for spice jars and food gifts. They can be simple or ornate.

Directions are given for making your labels from scratch; however, alternatives include ordering from a specialty catalog such as "Current"

(see page 85), purchasing pressure-sensitive labels available at office supply stores, and making copies of cartouches from clip art books (Figure 8-1). Reduce the cartouche on a photocopier if the original is too large.

Be creative when selecting your container. Use baby food jars for spices, catsup bottles for barbecue sauce, and jelly jars for Russian tea mix. Locate unusual bottles at flea markets and garage sales.

1. Select container. Wash and dry thoroughly. If desired, spray paint the lid in a suitable color. Dry thoroughly.
2. Determine size of label. Cut out varied size rectangles, squares, ovals, or other shapes and test the proportion.

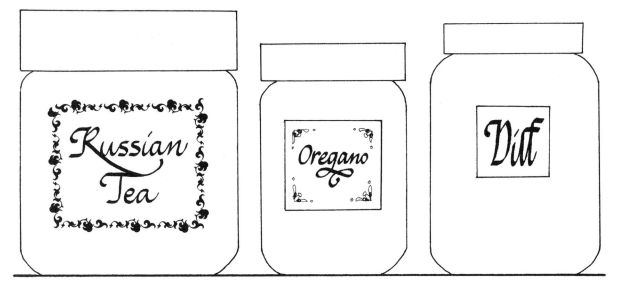

FIGURE 8-1

Poor Proportion. Label is too small.

FIGURE 8-2

FIGURE 8-3

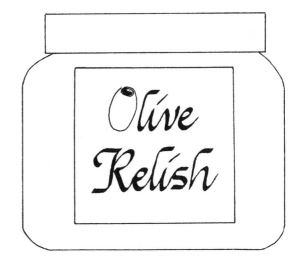

FIGURE 8-4

The size of the label should be in proportion to the size of the container (Figure 8-2).

3. Make label templates. Measure labels on paper (Figure 8-3). If an irregular shape is used make a template to trace. Trace shape on cardboard then cut out. Use the template to trace the shape on your paper.

4. Embellish. If desired, embellish your labels with a border or a symbol (Figure 8-4). I recommend that you photocopy your master sheet before cutting. Having a standard form permits you to easily make new labels, or if the label is likely to get mussed, replacing it is a snap (Figure 8-5).

5. Write label. Using a calligraphy pen, write labels on a separate piece of paper. With pencil, lightly mark the center of each label using a ruler (see page 49, Figure 7-18). Place guide sheet beneath paper and secure with tape or use a clipboard. Minimize errors by placing the prewritten label above the form to center the word. Write the label message on the form centering horizontally and vertically (see page 49, Figure 7-21). If you use the original sheet for labels, spray with fixative, then cut after fixative is completely dry.

6. Secure label. Spread a thin layer of rubber cement on back of label and on container. Let dry. Press label on container. When dry, rub off the excess rubber cement.

7. Special touches. If desired add a ribbon which reflects the spirit of the gift. Choose from a variety of ribbons:

▲ FIGURE 8-5

FIGURE 8-6 ▶

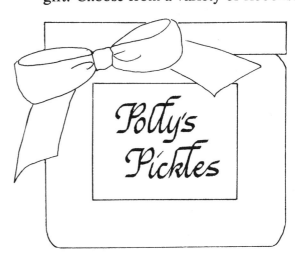

## ♪♪♪ Salsa ♪♪♪

1 c. chopped tomatoes
½ c. chopped onions
2 T. chopped green chilis
1 chopped garlic clove
1 T. vinegar
1 t. chili powder

Mix all ingredients together. Cover and refrigerate at least 2 hours before serving. Serve with tortilla chips.

FIGURE 8-7

gingham, plaid, satin, grosgrain, etc. (Figure 8-6). Label forms can also be used as gift tags and party favors (see page 65, Figures 8-26 through 8-28).

### RECIPES

Sharing recipes with friends and family provides many opportunities for using your calligraphy.

When someone requests one of my recipes, I am greatly complimented. I enjoy writing the recipe in calligraphy, and the recipient is always delighted to receive it.

If you have a speciality, why not frame that recipe and hang it in your kitchen (Figure 8-7)?

A challenging project that will definitely become a treasured heirloom is to make a book of your favorite recipes. Keep it simple by writing the recipe on notebook paper, then placing it in a binder. Or, write on unlined paper, then bind the book yourself (Figure 8-8). Consult an arts and crafts book on bookbinding for additional ideas. Make photocopies

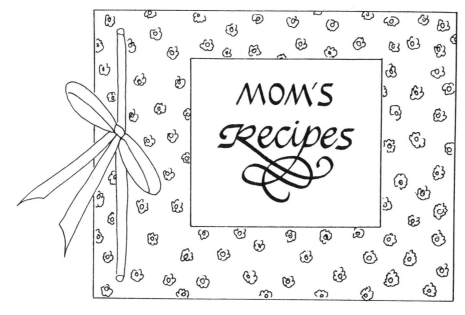

FIGURE 8-8

*Beef Stroganoff*

1 lb. sirloin steak, cubed
4-oz. can mushrooms, drained
1 can cream of chicken soup
1 cup sour cream

Sauté beef. Add mushrooms. Stir in
soup and sour cream. Heat until
hot. Serves 4.

FIGURE 8-9

of your recipes before binding. This allows you to give each child and grandchild a personal edition.

1. Experiment with form. Write the title and the recipe in various ways. Examples include: Listing the ingredients on one side and the method of preparation on the opposite side as in Figure 8-7, or listing the ingredients in one or two columns and the method in paragraph form underneath the ingredients (Figure 8-9). Go to the library and scan the cookbooks for additional ideas. Keep in mind that the recipe format must be utilitarian. Create an attractive design. But remember that it must be practical for the cook--easy to read and have a clear logical flow.

2. Create a recipe card. You can write the recipe on an index card, design a recipe form, or use a sheet of paper the size of your choice (Figure 8-10). Index cards are practical if you know your friend has a recipe box, but the other options are more interesting and creative.

3. Protect the recipe card. When the calligraphy is completely dry, spray with fixative to waterproof your project. If you prefer, plastic sleeves are available for index cards (see page 85 under "Current").

from **Sally's** kitchen

title:                                    serves:

FIGURE 8-10

# Grocery List

| Dairy | Meat | other |
|---|---|---|
| __ Milk | __ Chicken | __ Coffee |
| __ Butter | __ Beef | __ Sugar |
| __ Cheese | __ Pork | __ Flour |
| **Bakery** | **Produce** | __ Catsup |
| __ Bread | __ Apples | __ Mustard |
| __ Rolls | __ Oranges | __ Rice |
| **Frozen** | __ Lettuce | __ Soup |
| __ Juice | __ Carrots | __ Pasta |

FIGURE 8-11

## SHOPPING LISTS

Shopping lists are efficient time and energy savers (Figure 8-11). They make stocking your pantry a snap and eliminate inevitable human forgetfulness.

The example I use is a grocery list, but a picnic, gardening, and camping supply list are also practical ideas.

Take a few minutes to organize your needs, then make lists based on items that you regularly purchase.

1. List all items. Make a list of all items that you use. Scan your shelves, cabinets, refrigerator, and freezer to aid your memory.
2. Organize the list. You can categorize items according to type, where the items are stored, or according to where the items are located in your favorite store.
3. Write the list. Using two or three columns write the categorized list, leaving space to check items that are needed.
4. Photocopy the list.

## BOOKMARKS

Increase your reading pleasure by using a hand-crafted bookmark. Making a bookmark is a fun and simple project.

1. Determine size of bookmark. A size which works for pocket paperbacks as well as for coffee table art books is 7-by-1½-inch. But, vary the size to fit

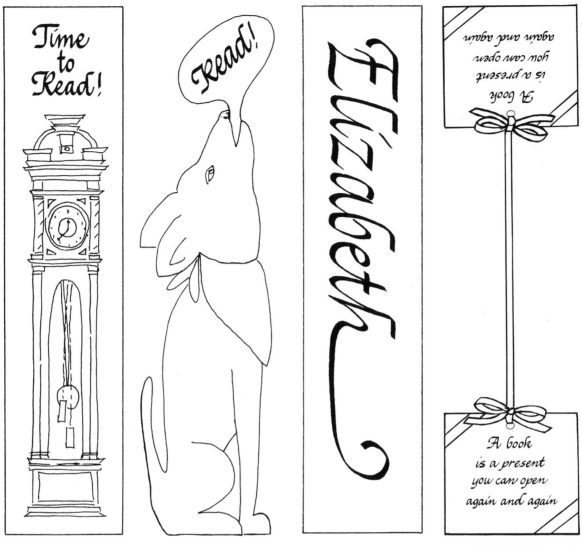

FIGURE 8-12                    FIGURE 8-13

the book if you wish.

2. Design the bookmark. Get ideas for bookmarks by looking at samples in book stores. Consider including a monogram, name, drawing, border, or quotation related to reading or books (Figure 8-12). Look for fitting quotations in the reference guides of the library.

3. Select paper. Use sturdy, high-quality paper. Mark size, then cut. Secure guide sheet behind paper. If paper is too thick draw pale pencil guidelines on paper (see page 49, Figure 7-22). They can be erased after your calligraphy has dried.

4. Execute design.

5. Special touches. Add a tassel by punching a hole in one end or in both ends of the bookmark; then, tie in a cord, tassel or ribbon (Figure 8-13). Fabric and craft supply stores have an array of intriguing tassel materials. Another idea is to laminate the bookmark. Check in the yellow pages of the phone book under "lamination" for businesses that offer such service. Or, purchase laminating materials from an office supply store and do it yourself.

FIGURE 8-14 Upper left and above.

FIGURE 8-15

FIGURE 8-16

## BOOK PLATES

*If* you value your books or have a special collection, consider making book plates. They identify you as the owner and emphasize the pride you have regarding your library.

Consider making CD, video tape, and cassette tape plates, also. They are excellent gifts for teenagers and for students living in dormitories.

1. Determine size. Book plates are generally small, typically 3¼-by-3¼-inch.
2. Design book plate. Use standard phrases plus your name: Ex Libris; From the collection of _____; From the library of _____; or This book belongs to _____ (Figure 8-14). If desired, use a quotation related to books, reading, or use a quote from a favorite author (Figure 8-15). After deciding on the text, select a border or decorations. Small cartouches make wonderful instant book plates (Figure 8-16).
3. Photocopy your design. Have extras on hand for a growing library.
4. Secure book plates. Using rubber cement or spray adhesive, glue the plate on the book's inside front cover.

## FAMILY TREES

*Researching* your family history can be a fascinating activity. After completing your research share your

FIGURE 8-17

findings with others by designing a genealogical chart or a family tree.

1. Make a rough draft. Your chart can feature your descendants. If you obtained extensive information your chart can feature your ancestors. Or, you may combine ancestors and descendants (Figure 8-17). As you write out your data, leave empty spaces for missing names which might be added later. Write each generation in one column; then writing from left to right, start with the oldest known relatives working your way up to the youngest members of your family. If you wish, include the brothers and sisters of great-grandparents, grandparents, and parents. Likewise, include cousins, if desired. Make your chart as complex or as simple as you wish.

2. Review the rough draft. Determine the spacing and size requirements of your final project. If you wish, you can allow extra space for birth, marriage, and death dates. Determine the width of the chart by multiplying the width of the column times the number of columns, adding to this figure the space between columns and the two side margins. Determine the length of the chart by counting the number of lines in the longest column plus the line spaces between names and the top and bottom margins. If you place a title at the top of the chart count the spacing needed for it. Titles need not be limited to the top of the chart. They can fill empty white space, balancing your design. If illustrations or decorations are planned, allow space for them when determining the size of your paper. Use borders to enhance your chart. Informal designs can be fun, too (Figure 8-18).

3. Write the final. After determining the spacing for the rough draft, you are ready to write the final. Prepare

the sheet by drawing guidelines with faint pencil lines. Use a T-square or large plastic triangle for speed. If desired, as you write the final, differentiate blood relatives from spouses that marry into the family. For example, write spouses names smaller using a smaller pen nib, or draw lines from parents to children to show exact lineage.

4. Add embellishments.

5. Reproduction. Consider having a printer make a reduction of your chart if it is large. This will allow you to make copies which will become treasured gifts for family members.

## CALENDERS

*C*alenders make great calligraphy projects which can add to your life "daily."

1. Determine size. Based on your needs, how much space do you need for individual days? Do you want to allow space for writing notes? With those considerations in mind, determine the size of one rectangle. Multiply the width of the rectangle by seven and the length of the rectangle by five (some months will require six). Divide the rectangle into five (six) rows with seven columns (Figure 8-19).

2. Plan design. After determining how much space is needed for the dates, prepare a basic rectangular form. If you want a more elaborate format, include a common illustration and/or border. For convenience, make twelve photocopies of the basic form. Add the name of the month, day of the week, and dates. Punch holes and tie with a ribbon (Figure 8-20) or bind with staples (Figure 8-21). One-page calendars typically do not

FIGURE 8-19

FIGURE 8-18

FIGURE 8-20

FIGURE 8-21

FIGURE 8-22

allow space for notes, but are
functional and decorative
(Figure 8-22). Illustrations and
borders add extra interest.

## REMINDERS AND SIGNS

*R*eminders and signs, just like
standard shopping lists, can
simplify your life.

If you habitually forget to turn
on your answering machine when leaving
home or, two miles down the road, you
worry that you did not unplug the iron,
why not take a few minutes to make
yourself a simple reminder?

Which of these would help you: Iron
unplugged? Answering machine turned on?
Lights out? Clock wound and alarm set?
Heat turned down? Meat thawed for dinner?

Signs are especially useful for
families. They can remind us to respect
each other's privacy. For example: Quiet;
No Smoking; Susie's Room; or Do not
disturb.

1. Determine size. Index cards are very
practical.
2. Design. Keep it simple by using only
calligraphy, or add a border or symbol
(Figure 8-23). Decorative cartouches and
clip art can jazz up your message
(Figure 8-24).

**63**

FIGURE 8-23

FIGURE 8-24

3. Execute.
4. Protect. Spray sign with fixative.
5. Display. Methods of displaying include taping to a door, framing, or using a thumb tack to adhere it to a bulletin board.

## GROWTH CHARTS

*G*rowth charts are delightful for young children. They love to see how fast they grow (Figure 8-25).

1. Select paper. Purchase a piece/roll of paper at least 48 inches long. Craft supply stores have rolls of paper.
2. Design. In pencil, mark left edge into 1-inch increments, marking the foot increments slightly longer. Using a fiber point pen, pen-and-ink, or strips of pre-cut colored tape, mark increments using equal lengths for 1-inch increments and longer lengths for foot increments. Write the numbers for feet. If desired, write the inches.
3. Personalize the chart. Make a simple drawing of the child's favorite animal.

FIGURE 8-25

FIGURE 8-26 Above and upper right.

FIGURE 8-27

Hang a sign around it's neck. Write the child's name on the sign. If you are unsure about drawing an animal or other design, look at children's books for ideas.

## TAGS

*M*aking tags for crafts, garage sales, and gifts are an efficient use for your calligraphy.

1. Determine size. Prepare a one-piece or folded tag. A suggested size for a one-piece tag is 2-by-3-inches and 4-by-3-inches for a folded tag.
2. Design the form. Include a border, symbol, or illustration if you wish (Figure 8-26). Cartouches make elegant tags (Figure 8-27). Reduce the cartouche on a photocopier, if necessary.
3. Personalize. Write the name of the recipient or the price on the tag.
4. Special touches. Tape to package/ article or punch a hole in tag and attach with yarn, string, or ribbon (Figure 8-28).

FIGURE 8-28

# Entertaining

---

I want my guests to feel special when they visit my home. With a minimum of time and effort I create little "extras" which add a personal touch to social occasions. The following projects are simple, yet effective ways to let people know you care about them.

## PLACE CARDS

Place cards add a festive touch to any meal, regardless of whether it is casual or formal.

1. Determine size. Draw rectangles on your paper to represent the place cards (Figure 9-1). I prefer 3½-by-2½-inches, which is folded in half for a self-standing card (Figure 9-2).

2. Design card. If you prefer, create more ornate forms by adding a border or symbol (Figure 9-3). Using calligraphy pen, write your guest list on a separate sheet of paper. Mark the center of each name with a ruler (see page 49, Figure 7-18). If the paper is translucent, place guide sheet under card form. Minimize errors by placing the prewritten

FIGURE 9-3

FIGURE 9-4

FIGURE 9-1

FIGURE 9-2

FIGURE 9-5

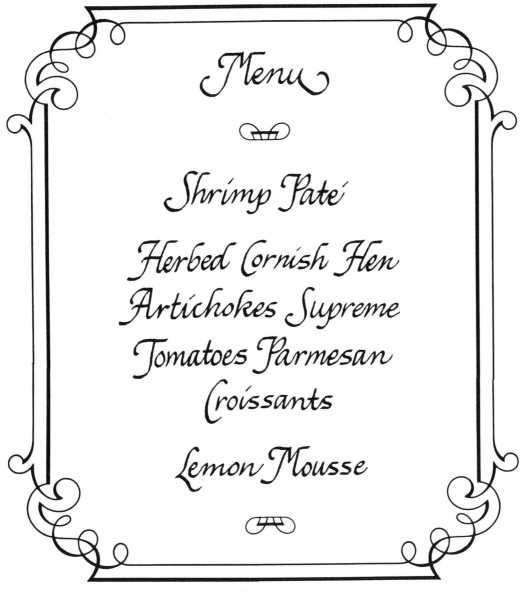

*Menu*

*Shrimp Paté*

*Herbed Cornish Hen*
*Artichokes Supreme*
*Tomatoes Parmesan*
*Croissants*

*Lemon Mousse*

FIGURE 9-6

name above the form. Write the name on the form centering horizontally and vertically (see page 49, Figure 7-21). Black ink and dignified letters are best for formal dinners (Figure 9-4), but use your creativity for informal meals and parties with particular themes (Figure 9-5).

3. Protect. Spray card with fixative to waterproof. Save your place cards because they can be reused.

4. Reproduction. If you frequently give special dinners, consider photocopying a sheet of forms. Making new place cards will be a snap.

## MENUS

*S*et the stage for elegant dinners as well as informal parties by giving your guests a preview of the menu.

1. Design menus. Consider using the spirit of the event or type of food to be served as a design theme. Do you

Menu
Tuna Mousse
Chicken Cordon Bleu
Tossed Salad
New Potatoes
Rolls and Butter
Chocolate Cake

FIGURE 9-7

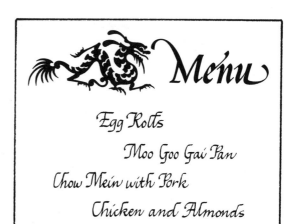

Menu

Egg Rolls
Moo Goo Gai Pan
Chow Mein with Pork
Chicken and Almonds
Steamed Rice
Fortune Cookies
Hot Tea

FIGURE 9-8

prefer a formal symmetrically balanced menu (Figure 9-6) or something more informal (Figure 9-7). There are clip art books which feature menu forms (Figure 9-8). How about a frame or cartouche (see Figure 9-6)? An illustration or clip art adds personality (Figure 9-9).

2. Experiment. Text arrangement can create mood. Observe the different effects achieved by symmetrical, flush left, and ragged placed texts in Figures 9-6 through 9-9.

3. Prepare final. After deciding how to write your menu prepare your final. Write the menu on the paper, then add the illustration, border, etc. Or, in you prefer, do the illustration first then add the menu.

4. Protect. Spray with fixative to waterproof. Menus can be used again.

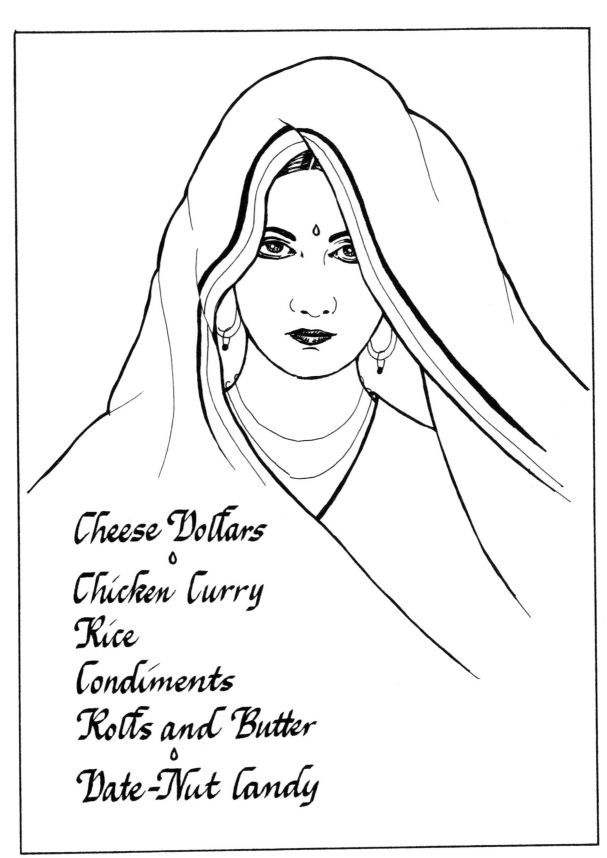

Cheese Dollars
o
Chicken Curry
Rice
Condiments
Rolls and Butter
o
Date-Nut Candy

FIGURE 9-9

FIGURE 9-10

FIGURE 9-11

## FOOD GIFTS/PARTY FAVORS

*W*hen your guests leave give them a special treat to enjoy later (Figure 9-10). Include a hand-made tag or label (see page 65, Figures 8-26 through 8-28).

Your friends will appreciate your thoughtfulness.

## SWEET DREAMS

*H*ouse guests deserve attention, also. Write "Sweet Dreams" on a card in a plain or ornate style (Figure 9-11). Add a border or symbols, if desired. Turn down the sheets, then place the card on your house guest's pillow beside a candy bar or a piece of homemade candy.

# *Literature*

Do you have a favorite quote, Bible verse, poem, or song? If so, enjoy it everyday by writing it in calligraphy and framing.

I have an assortment of favorite quotations throughout my home. Quotes, Bible verses, poems, and song lyrics can be hung anywhere you like, but most typically, they are located in informal areas such as the kitchen, bathroom, or den. I also hang them in my husband's wood workshop and my art studio.

Some of my quotations are humorous to cheer me up; others are serious, inspiring me to work harder toward my goals. Although my framed quotes do not take very long to complete, they enrich my life daily.

Quotations are a good way to share your thoughts with guests. By framing what is important to you, regardless of whether it is serious or humorous, you reveal your personality to others.

In fact, why not have a "Quote of the Month"? Use a frame that is easy to take apart so you can feature a special quote each month. Hang it on a wall or set it on a desk like a photograph (Figure 10-1). Put a "Quote of the Month" on your desk at work, also.

Find quotes having personal significance in the reference section of your library.

Magazines frequently use quotes and poems as fillers. Clip your favorites and file for future use.

*Art is the only way to run away without leaving home*

TWYLA THARP

FIGURE 10-1

> The most popular
> labor saving device
> is still money. PHYLLIS GEORGE

FIGURE 10-2

> The future is TODAY...
> there is no tomorrow.
>
> SIR WILLIAM OSTER

FIGURE 10-3

## QUOTE/BIBLE VERSE

Framing a favorite quote or Bible verse can add sparkle to your day and uplift your spirits.

1. Determine size. Consider the finished project as a whole. Small is generally best because most quotations do not require much space. The proportion of the overall piece should be in proportion to the size of the space used by the quote. Allow ample margins so that the quote does not look crowded. On the other hand, excessive space overwhelms your message. Strive for a balance (Figure 10-2). For convenience and economy, I prefer a standard size (3-by-5-inches) which allows me to use standard frames and mats. Index cards are suitable for informal use. I like to tape them on my bathroom mirror and refrigerator.

2. Experiment with presentation. The objective is to write the quotation in a manner that enhances the meaning for the reader (Figure 10-3). Read it aloud. What is the key word(s)? Should it be emphasized by writing it larger and bolder, with a scroll pen, in a different color, or in a different style? If certain words or phrases are repeated, could they be used to make an interesting design? Sometimes simple is best. A decorated first letter can be powerful. Obviously, there are no rules; arrange the words according to the message. When planning

72

WE don't see
things as
they are

WE see things
as we are.

ANAÏS NIN

FIGURE 10-4

your design do not forget to identify the author of the quotation.

3. Execute design. If you are using thin paper, place a guide sheet under the paper and write the quote based on your design. If you are using opaque paper, lightly draw pencil guidelines on your paper (see page 49, Figure 7-22). Erase the guidelines when ink is completely dry.

4. Mat/frame the quotation. Would the design be improved with a mat, French mat (see page 35, Figure 4-22) or border (Figure 10-4)? The frame should focus attention on the quote, not overwhelm it.

## POEMS/SONG LYRICS

Poems and song lyrics have tremendous emotional power. Enjoy their special magic daily by framing your favorites.

1. Determine size. Count the lines and spacing of the original piece. Allow for top, bottom, and side margins. And, do not forget to include space for the title and the poet's/lyricist's name.

2. Design the piece. Write the exact words, punctuation, line length, etc., as the poet/lyricist composed them. However, if the poem has several verses/stanzas

## Trees

### JOYCE KILMER

*I think that I shall never see*
*A poem lovely as a tree.*

*A tree whose hungry mouth is prest*
*Against the earth's sweet flowing breast;*

*A tree that looks at God all day,*
*And lifts her leafy arms to pray;*

*A tree that may in Summer wear*
*A nest of robins in her hair;*

*Upon whose bosom snow has lain;*
*Who intimately lives with rain.*

*Poems are made by fools like me,*
*But only God can make a tree.*

FIGURE 10-5

consider using a decorated initial or enlarging the first letter or word (Figure 10-5). Borders can be very effective in establishing mood (Figure 10-6). Airy, open spacing creates a more light-hearted effect than condensed spacing (Figure 10-7). For the lyrics of your favorite song, consider obtaining blank music sheet paper. Write the notes and add the lyrics, then frame. Remember to include the poet's/lyricist's name as part of your design.

3. Execute design. If you are using thin paper, place a guide sheet under the paper then write the poem/song based on your design. If the paper is opaque, draw light pencil guidelines on your paper (see page 49, Figure 7-22). Erase the guidelines when the ink is completely dry. Since you are probably using copyrighted material, it is illegal for you sell this project without the permission of the poet/lyricist. It is all right to do this for your personal use or as a gift.

74

# Amazing Grace

Amazing grace, how sweet the sound
That saved a wretch like me;
I once was lost, but now I'm found,
Was blind, but now I see.

'Twas grace that taught my heart to fear,
And grace my fears relieved;
How precious did that grace appear,
The hour I first believed.

Rev. John Newton

FIGURE 10-6

If I can stop one heart from breaking,
I shall not live in vain;
If I can ease one life the aching,
Or cool one pain,
Or help one fainting robin
Unto his nest again,
I shall not live in vain.

Not in Vain

Emily
Dickinson

If I can stop one heart from breaking,

I shall not live in vain;

If I can ease one life the aching,

Or cool one pain,

Or help one fainting robin

Unto his nest again,

I shall not live in vain.

Not in Vain

Emily

Dickinson

FIGURE 10-7

76

# Community

Contributing to your community is a rewarding experience. If you are a member of a club, church, or organization, your calligraphic talent can be a valuable asset to the group. Volunteering your services can be an opportunity for active participation with the group as well as for making new friends.

Your calligraphy can be utilized in many ways. For example, the programs that you design for dance or piano recitals and church performances not only will commemorate the special event but will become treasured scrapbook mementos. Preparing certificates, diplomas, and awards can be as rewarding an experience for you as for the recipient. Club newsletters also offer great opportunities to develop your creativity and showcase your calligraphy.

When creating artwork for an organization you need to consider certain details which may not apply when you are doing a project for yourself or as a gift. Before starting the project, make certain that the person or committee in charge of the project provides you with all the pertinent information.

Information that you need includes answers to the following questions:

1. What is the purpose of the project? The purpose will set the tone for your approach.
2. Does the finished product need to be formal or informal?
3. Does the format need to be vertical or horizontal?
4. Must the work be a particular size?
5. Must the work be done on certain materials?
6. Is there a budget for materials? You should be reimbursed for materials purchased. Keep your receipts.
7. Are you creating a one-of-a-kind project or will the work be reproduced?
8. Who is responsible for having the piece printed?
9. What is the budget for reproduction? This will determine if you can use color, etc.
10. Will the work be matted/framed? Who will be responsible for matting/framing?
11. Does the work have to be finished by a particular date?

This information will minimize misunderstandings. I have also learned to be direct with my requirements to customers. For example, when I do volunteer work, I require the creative freedom to design the project as I wish. I will, however, follow the preestablished customer guidelines (as noted in items 1 through 11 above) while creating my work.

As the artist, I have creative control over the project. So, when volunteering, I make it clear that my finished design must stand--extensive changes are not possible. More importantly, I make it understood that my work will not be altered without my consent.

However, when I am paid for my services, the customer has more artistic control over my design.

Regardless of whether or not I am being paid, I always show a portfolio of my work to the person(s) in charge before I begin a project. This allows my customers to evaluate my style according to their preferences.

The key to a mutually successful relationship is understanding. Make your requirements as clear as the specifications the customer has given you.

## PROGRAMS

*A* well designed program is both beautiful and functional. In future years it becomes a treasured keepsake.

1. Obtain pertinent information. Possible information you will need includes the following: date, time, location, names of participants, and program details.
2. Determine size. For convenience and economy use 8½-by-11-inch. This size is easily reproduced. The program can be folded in different ways (Figure 11-1). Folded programs require a cover design.

FIGURE 11-1

Culver City Realtors
*Annual Awards Banquet*

Welcome – Alan Daniel
Invocation – Mark Bennett

*Dinner*

President's Presentation – Meg Ames
Sales Award – Tim Porter
Circle of Excellence – Joan Lopez
Closing Remarks – Jim Klar

Formal

Culver City Realtors
*Annual
Awards Banquet*

Welcome – Alan Daniel
Invocation – Mark Bennett

*Dinner*

President's Presentation – Meg Ames
Sales Award – Tim Porter
Circle of Excellence – Joan Lopez
Closing Remarks – Jim Klar

Informal

FIGURE 11-2

Margins are too generous.

Margins are in proportion to the text.

FIGURE 11-3

3. Consider budget. Decide which style best suits the event and your budget. If you are having the program commercially printed, remember that folded designs cost more.

4. Design program. Write the program text, then experiment with different layouts. What looks best and expresses the correct mood (Figure 11-2)? Legibility and a logical sequence are imperative to an effective program. It is critical that the sequence of events are easy to follow. Pay attention to the overall amount of information on each page. Allow plenty of breathing space, (i.e., margins), but do not let the margins overpower the design by being too generous (Figure 11-3). While experimenting with the text, consider the cover design (if applicable) and suitable text embellishments. You can keep your design plain or add a border, illustration, or logo (Figure 11-4).

5. Limit lettering styles. Do not use more than two lettering styles. It is too confusing and looks chaotic. If extensive text is used, use a typewriter or a computer for the text and calligraphy

FIGURE 11-4

FIGURE 11-5

for the title and major headings
(Figure 11-5).
6. Create final product.
7. Reproduction. Before taking your work
to the printer, run a test photocopy to
check for errors. Select suitable paper
considering the budget and the
formality of the event.

## AWARDS/CERTIFICATES/DIPLOMAS

*R*eceiving an award, certificate, or a
diploma is a special event. A
beautifully designed document makes the
occasion additionally memorable.

1. Obtain pertinent information. Before
designing make certain that you know
the exact details that must be included
on the document: logo, seal, embossing,
number of lines for signatures, date, and
specific wording.
2. Determine size. If you design a form
that will be reproduced, use a standard
size so that reproduction costs will be
minimal. I recommend 8½-by-11-inches,
8½-by-14-inches, or 11-by-14-inches.
3. Experiment with design. After you are
certain of the specific requirements,
experiment with various designs. Try both
vertical and horizontal formats. When
designing text presentation, consider
embellishments. Embellishments are not
afterthoughts; they need to be part of
the whole design. Remember these tips:
A. Formal. Formal is very dignified and
serious. It is the appropriate choice
for documents that commemorate
achievements (Figure 11-6). Avoid
monotony by varying the spacing. Create
a block form or center each line.
B. Informal. Try ragged, flush left,
flush right, and free-form arrangements
of the text. Make certain to balance
your design if it is asymmetrical
(Figure 11-7). Seals and ribbons create
balance and are very impressive. Seals
can be purchased at office supply and
stationery shops.

FIGURE 11-6

80

4. Execute design. Select quality paper if you are producing a one-of-a-kind document. Using fine paper not only enhances the beauty of your calligraphy, but also adds to the dignity and stature of the document.

5. Reproduction. Before taking your final document to the printer, run a test photocopy to check for errors. Select quality paper for your printed document. Order extra copies; extras will make filling in names and dates less tense.

6. Present to recipients. Roll up the document and tie it with a ribbon, place it in a leather folder, or frame; then present the document to the lucky recipient.

7. Optional method. If time is very limited, a preprinted form can be used. They are available at office supply and stationery shops. Write the name on a separate sheet of paper, then measure to locate center of the name. Locate center of line for name on form, then place the prewritten name above the line provided for the name (see page 49, Figure 7-21). Write in the name. Personalize the form with a seal and ribbon, if desired.

## NEWSLETTER

*S*how off your artistic ability by designing the newsletter of your club or organization.

1. Determine size. For convenience and economy 8½-by-11-inches or 8½-by-14-inches are the most practical sizes for newsletters. These sizes are easily reproducible.

FIGURE 11-7

2. Design newsletter. The extent that calligraphy is used in a newsletter depends on the length of the newsletter. For a one-page newsletter the entire newsletter could be hand lettered (Figure 11-8). Break the information into two columns because it is easier to read. For sake of unity, do not utilize more than two lettering styles. For two-page or larger newsletters I recommend using a typewriter or a computer for the text. Write the title and major headings in calligraphy (Figure 11-9).

3. Newsletter title. A clever newsletter title makes a great masthead. Get members to submit ideas, then select by democratic vote. Add an illustration or logo to the masthead on the first page, if desired (see Figure 11-8).

4. Extra design elements. Illustrations, clip art, cartoons, spot drawings, or designs can be used for additional interest and to fill excessive white space. Always select artwork in the style of your newsletter (see Figure 11-9).

5. Newsletter mailings. If the newsletter is to be mailed, leave space in your layout for the address label (Figure 11-10). Depending on the thickness of the newsletter, I recommend folding in half or thirds.

6. Prepare layout. Prepare each page by pasting up the elements (if using typewriter or computer) or write out. If you make a mistake when writing, simply paste in a correction (see page 40, Figure 6-1 and 6-2). If you have a desktop publishing program, the entire text can be done on the computer. Paste in your calligraphy titles and art work. Be concerned about margins. Allow enough space so that the text does not look crowded, but not so much space that it makes your text look insignificant.

7. Reproduction. Before taking the newsletter to the printer, run a test photocopy of each page to check for errors. Edit for misspelled words, accurate information, and the visual

FIGURE 11-8

FIGURE 11-9

appearance. If shadows appear on the photocopy, eliminate with correction fluid.

8. Special accents. Consider printing the newsletter in a colored ink, suiting the mood of the month; i.e., green for March, red for February. Or have the newsletter printed on colored paper.

9. Feature article. Even if you are not in charge of the newsletter, your calligraphy can enhance the product immensely. Perhaps you could write out the menu for your club's monthly luncheon, a recipe, poem, quote of the month, or a "bio" of the guest speaker.

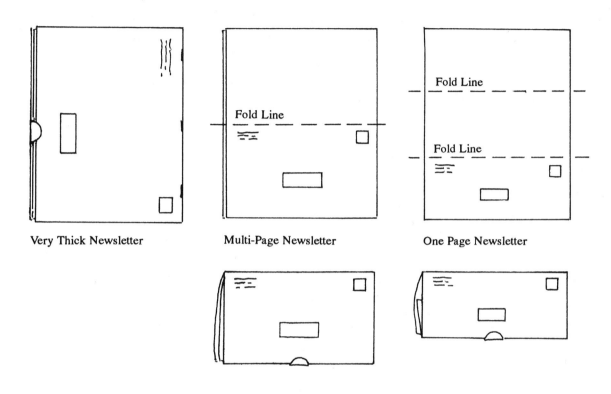

Very Thick Newsletter          Multi-Page Newsletter          One Page Newsletter

FIGURE 11-10

# Gift List

___

Almost all of the projects featured in this book make excellent gifts. Fortunately, most of the items are inexpensive to make.

If you create a project which is especially pleasing consider reproduction so that it can be shared with your friends. Your projects will become treasured heirlooms.

Gift ideas are listed below followed by the page numbers that feature examples:

Awards  81
Bible verses  71-73
Book plates  60
Bookmarks 59
Calendars  62, 63
Family trees  61, 62
Labels for spice jars and food gifts
  54, 55, 65, 70
Monograms  45, 46
Notecards  43, 47
Poems  74, 76
Postcards  48
Quotes  71-73
Recipes  56, 57
Song lyrics  75
Stationery  42-46, 52

**Especially for children:**

Growth charts  64
Labels for records, CDs, video tapes,
  and cassettes  60
Room signs 64

# Resources

## ART/CALLIGRAPHY SUPPLIES

Art Supply Warehouse, 360 Main Avenue (Route 7), Norwalk, CT 06851 1-800-995-6778

Artists' Connection, 20 Constance Court, P.O. Box 13007, Hauppauge, NY 11788-0533   1-800-851-9333

Current, Inc., The Current Building, Colorado Springs, CO 80941 (Recipe cards and clear plastic sleeves for recipe/index cards. Canning/food container labels) 1-800-525-7170

Dick Blick Art Materials, P.O. Box 1267, Galesburg, IL 61402   1-800-447-8192

The Jerry's Catalog, P.O. Box 1105, New Hyde Park, NY 11040 1-800-827-8478

Sax Arts & Crafts, P.O. Box 51710, New Berlin, WI 53151 1-800-323-0388

## CALLIGRAPHY SUPPLIES

Hunt Manufacturing Co., P.O. Box 5830 Statesville, NC  28677 1-800-TRY-HUNT

Ken Brown Studio, P.O. Box 22, 404 "E" McKinney Pkwy., McKinney, TX 75069 1-800-654-6100

Pendragon, P.O. Box 1995, Arlington Heights, IL  60006 1-800-775-7367

Sheaffer Inc., 301 Avenue H, Fort Madison, IA 52627 1-800-346-3736

## CLIP ART

Dover Publications, Inc., 31 East 2nd Street, Mineola, NY 11501 (Request calligraphy and clip art catalog.)

Graphic Products Corporation, 1480 S. Wolf Road, Wheeling, IL  60090 (Request information regarding available titles in their clip art library. Also ask for list of retailers in your vicinity.)

## FRAMING AND MATTING

American Frame Corp., 400 Tomahawk Drive, Maumee, OH 43537 1-800-537-0944

Archival Products, L.A., 4129 Sepulveda Boulevard, Culver City, CA  90230

Documounts Framing Service, 3709 West 1st, Eugene, OR  97402 1-800-769-5639

Stu-Art, 2045 Grand Avenue, Baldwin, NY 11510  1-800-645-2855

Wholesale Frame Service, P.O. Box 11047, High Point, NC 27265  1-800-522-3726

## NEWSLETTERS

BROWNLINES, Ken Brown Studio, P.O. Box 22, 404 "E" McKinney Pkwy., McKinney, TX 75069  1-800-654-6100 Charter Membership @ $23 for 6 issues plus additional materials. Regular subscription @ $18 for 6 issues.

DRAGON RAG, P.O. Box 327, Afton, MN 55001  612-436-2046. One year (4 issues) @$6.00 (Price subject to change).

## REFERENCE GUIDES

Bartlett, John. FAMILIAR QUOTATIONS. Boston: Little, Brown, and Company, 1980.

Collison, Robert and Mary, eds. DICTIONARY OF FOREIGN QUOTATIONS. New York: Facts on File, 1980.

Smith, William James and William F. Bernhardt, eds. GRANGER'S INDEX TO POETRY. New York: Columbia University Press, 1982.

Edwards, Tryon, ed. THE NEW DICTIONARY OF THOUGHTS: A CYCLOPEDIA OF QUOTATIONS FROM THE BEST AUTHORS OF THE WORLD. New York: Standard Book Company, 1957.

Meredith, J. L., ed. MEREDITH'S BOOK OF BIBLE LISTS. Minneapolis, Minnesota: Bethany Fellowship, 1980.

OXFORD DICTIONARY OF QUOTATIONS. Oxford, England: Oxford University Press, 1979.

# Calligraphy Organizations

## California

PACIFIC SCRIBES
P.O. Box 3392
Santa Clara, CA 95055

SOCIETY FOR CALLIGRAPHY
P.O. Box 64174
Los Angeles, CA 90064

## Colorado

COLORADO CALLIGRAPHERS'
GUILD
P.O. Box 6746
Denver, CO 80206

## Florida

FLORIDA GULF COAST
SOCIETY OF SCRIBES
Post Office Box 1788
St. Petersburg, FL 33731

## Illinois

CHICAGO CALLIGRAPHY
COLLECTIVE
P.O. Box 11333
Chicago, IL 60611

## Maine

THE CALLIGRAPHERS
OF MAINE
P.O. Box 2751
South Portland, ME 04116-2751

## Michigan

MICHIGAN ASSOCIATION
OF CALLIGRAPHERS
P.O. Box 55
Royal Oak, MI 48068-0055

## Minnesota

COLLEAGUES OF
CALLIGRAPHY
P.O. Box 4024
St. Paul, MN 55104

## Nevada

SOCIETY OF DESERT
SCRIBES
P.O. Box 19524
Las Vegas, NV 89132

## New York

SOCIETY OF SCRIBES, LTD.
P.O. Box 933
New York, NY 10150

## North Carolina

LETTERING ARTS
ASSOCIATION
P.O. Box 18122
Asheville, NC 28814

## Ohio

CALLIGRAPHY GUILD OF
COLUMBUS
P.O. Box 14184
Columbus, OH 43214-0184

## Oregon

THE CALLIGRAPHERS' GUILD
P.O. Box 304
Ashland, OR 97520

PORTLAND SOCIETY FOR
CALLIGRAPHY
P.O. Box 4621
Portland, OR 97202

## Pennsylvania

CALLIGRAPHERS' GUILD OF
NORTHEASTERN PENNSYLVANIA
c/o RR 5  Box 5536
Moscow, PA  18444-9163

PHILADELPHIA
CALLIGRAPHERS
SOCIETY
P.O. Box 7174
Elkins Park, PA  19117

VILLAGE CALLIGRAPHERS
GUILD
P.O. Box 194
Jamison, PA  18929

## Texas

HOUSTON CALLIGRAPHY
GUILD
1953 Montrose
Houston, TX  77006

KALIGRAFOS DALLAS
CALLIGRAPHY SOCIETY
2917 Swiss Ave.
Dallas, TX  75204

SAN ANTONIO
CALLIGRAPHERS GUILD
P.O. Box 6476
San Antonio, TX  78209

## Washington

WRITE ON CALLIGRAPHERS
P.O. Box 277
Edmonds, WA  98020

## Wisconsin

THE WISCONSIN CALLIGRAPHERS'
GUILD
P.O. Box 55120
Madison, WI  53705-8920

## Foreign Countries

BOW VALLEY CALLIGRAPHY
GUILD
P.O. Box 1647, Station M
Calgary, Alberta T2P 2L7
Canada

THE CALLIGRAPHIC ARTS
GUILD OF TORONTO
P.O. Box 115
Willowdale, Station A
North York, Ontario
M2N 5S7
Canada

VERENIGING MERCATOR
Rembrandtstraat 3
2712 SE Zoetermeer
Holland

THE SOCIETY FOR ITALIC
HANDWRITING
Secretary: Janet Pamment
Timbertrack
53 Sea Avenue
Rustington, West Sussex
BN16 2DN
England

THE SOCIETY OF SCRIBES
AND ILLUMINATORS
Hon. Secretary Mrs. Susan
  Cavendish
54 Boileau Rd.
London SW13 9BL
England

# GUIDE SHEET - FINE

**GUIDE SHEET - MEDIUM**

# GUIDE SHEET - BROAD

# Bibliography

## CALLIGRAPHY INSTRUCTION

Brown, Ken. THE KEN BROWN CALLIGRAPHY HANDBOOK. Hugo, Oklahoma: The Ken Brown Studio of Calligraphic Art, 1982.

_____. THE KEN BROWN CALLIGRAPHY RESOURCE GUIDE. Hugo, Oklahoma: The Ken Brown Studio of Calligraphic Art, 1987.

_____. OLD ENGLISH CALLIGRAPHY. Hugo, Oklahoma: The Ken Brown Studio of Calligraphic Art, 1984.

Butterworth, Emma Macalik. THE COMPLETE BOOK OF CALLIGRAPHY. San Francisco: Thorsons, 1991.

Camp, Ann. PEN LETTERING. New York: Taplinger Publishing Company, Inc., 1984.

David, Stuart. HOW TO BE A SUCCESSFUL LETTERING ARTIST. New York: Art Direction Book Company, 1987.

Douglass, Ralph. CALLIGRAPHIC LETTERING WITH WIDE PEN AND BRUSH. New York: Watson-Guptill Publications, 1967.

Graham, David. COLOUR CALLIGRAPHY. Tunbridge Wells, Kent (Great Britain): Search Press Limited, 1991.

Lincoln, Abraham. ITALIC CALLIGRAPHY. Brookville, Ohio: Calligrafree, 1984.

Lynskey, Marie. CREATIVE CALLIGRAPHY. San Francisco: Thorsons Group, 1984.

McMannon, Karen. CALLIGRAPHY TECHNIQUES: FORMAL ITALIC. Cincinnati, Ohio: North Light Books, 1987.

_____. CALLIGRAPHY TECHNIQUES: ITALIC CURSIVE. Cincinnati, Ohio: North Light Books, 1987.

_____. CALLIGRAPHY TECHNIQUES: UPPER CASE ITALIC. Cincinnati, Ohio: North Light Books, 1987.

Nash, John R. and Gerald Fleuss. PRACTICAL CALLIGRAPHY. London: Hamlyn Publishing Group.

Norman, Will. CALLIGRAPHY MADE EASY. New York: Beekman House, 1983.

Reynolds, Lloyd J. ITALIC CALLIGRAPHY AND HANDWRITING. New York: Pentalic Corporation, 1969.

Stoner, Charles and Henry Frankenfield, editors. SPEEDBALL TEXTBOOK. Philadelphia: Hunt Manufacturing Company, 1972.

Taipale, Denys. ITALIC CALLIGRAPHY. Great Falls, Montana: Westwind Graphic Design, Inc., 1983.

Wilson, Diana Hardy. THE ENCYCLOPEDIA OF CALLIGRAPHIC TECHNIQUES. Philadelphia: Running Press, 1990.

Wotzkow, Helm. THE ART OF HAND LETTERING. New York: Dover Publications, Inc., 1967.

## CALLIGRAPHY PROJECTS

Glander-Bandyk, Janice and Dennis Droge. WOMAN'S DAY BOOK OF CALLIGRAPHY. New York: Simon and Schuster, 1980.

Shepherd, Margaret. CALLIGRAPHY FOR CELEBRATING YOUR NEWBORN. Stamford, Connecticut: Longmeadow Press, 1991.

_____. CALLIGRAPHY FOR CELEBRATING YOUR WEDDING. Stamford, Connecticut: Longmeadow Press, 1991.

_____. CALLIGRAPHY PROJECTS FOR PLEASURE AND PROFIT. New York: Putnam Publishing Group, 1983.

_____. USING CALLIGRAPHY. New York: Macmillan Publishing Company, 1979.

## CARTOUCHES AND SMALL FRAMES

Gillon, Edmund V. Jr., ed. CARTOUCHES AND DECORATIVE SMALL FRAMES. New York: Dover Publications, Inc., 1975.

## LAYOUT

Furber, Alan. LAYOUT AND DESIGN FOR CALLIGRAPHERS. New York: Taplinger Publishing Company, Inc., 1984.

Furber, Alan. USING CALLIGRAPHY: LAYOUT AND DESIGN IDEAS. New York: Sterling Publishing Company, Inc., 1992.

Shepherd, Margaret. BORDERS FOR CALLIGRAPHY. New York: Macmillan Publishing Company, 1984.

## LEFT-HANDED CALLIGRAPHY

Rivers, Betsy. INSIGHTS INTO LEFT-HANDED CALLIGRAPHY. Pepperell, Massachusetts: D3H Associates, 1984.

Studley, Vance. LEFT-HANDED CALLIGRAPHY. New York: Van Nostrand Reinhold Company, 1979.

## SCROLLWORK AND PICTORIAL CALLIGRAPHY

Lupfer, E.A. ORNATE PICTORIAL CALLIGRAPHY. New York: Dover Publications, Inc., 1982.

Schwandner, Johann Georg. CALLIGRAPHY: CALLIGRAPHIA LATINA. New York: Dover Publications, Inc., 1958.

van Horicke, Baldri. MASTER ALBUM OF PICTORIAL CALLIGRAPHY AND SCROLLWORK. New York: Dover Publications, Inc., 1985.

# *Index*

---

## COLOPHON

The majority of calligraphy samples were written with a Sheaffer pen and Sheaffer jet black ink cartridges with either a fine, medium, or bold nib. Some samples were written with a Speedball C-0, C-2, or C-4 nib plus holder and India ink. All work was completed on Xerox 4200 DP copier and laser printing paper.

# About the Artist

Joyce Ryan is an accomplished calligrapher as well as author, artist, and teacher. She shares her enthusiasm for calligraphy and art by writing and illustrating instruction books and by teaching classes. Since graduation from the University of Georgia with a BFA degree in art she has pursued a successful career as a commercial artist and writer. Her publications include: TRAVELING WITH YOUR SKETCHBOOK, SEOUL TRAVEL GUIDE, SCENES OF SOUTHERN ARIZONA, SEOUL SKETCHES, and THE HAPPY CAMPER'S GOURMET COOKBOOK. Listed in Who's Who in 1990, she has exhibited extensively in the United States and abroad. Her drawings and paintings are in private collections throughout the United States, Europe, Japan, and Korea.

**BUTTERFLY
BOOKS**

4210 Misty Glade
San Antonio, Texas 78247

## ORDER FORM

Please send me ___ copies of CALLIGRAPHY–
ELEGANT AND EASY @ $12.95 each.

**Total amount for books:**      $ _____

**$2.00 for postage/handling**      $ _____

**Texas residents add 8% sales
tax ($l.04 for 1 book)**      $ _____

**Total amount enclosed:**      $ _____

Please make check payable to BUTTERFLY BOOKS.

Mail book(s) to:

Name:_____

Address:_____

City:_____

State/Zip:_____

Thank you for your order!

The End